BARRON'S ART HANDBOOKS

MIXING COLORS
1. WATERCOLOR

BARRON'S ART HANDBOOKS

MIXING COLORS
1. WATERCOLOR

BARRON'S

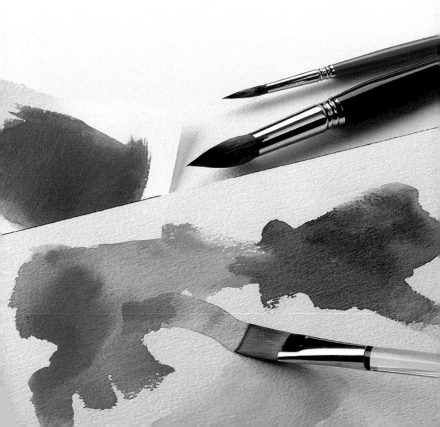

CONTENTS

COLOR THEORY

Fundamentals and Origin

Color is a quality of the visual sensation. This effect is produced in the retina by light within the wavelength of 400 to 760 nanometers. Color is a property of objects seen in daylight. We say "daylight" because without light objects do not have color. This is because color is the result of a reflection in our eyes of the light that is cast on objects.

This experience led Isaac Newton (1642–1727) and Thomas Young (1773–1829) to establish the principle that *light is color.*

Newton shut himself up in a completely dark room and let in a single beam of light through a tiny hole. Then he intercepted the ray with a prism and managed to disperse the white light into the six colors of the spectrum.

Years later, Young did an experiment that was the opposite of Newton´s: the physicist reconstructed light. The result of these investigations proved that the colors of the spectrum can be reduced to three basic colors: intense green, intense red, and dark blue. Using three lanterns, Young projected three beams of light through filters of these three colors, superimposing one on top of the other. The mixture of the three colors produced white, that is to say, the light was reconstructed. This experiment confirmed the first principle of light: three beams of light, one dark blue, one intense red, and another intense green, when superimposed on one another, give us as clear, white light; in other words, these colors reconstruct light.

400 450 480 560 590 760

Wavelength corresponding to the colors of the spectrum produced in our retina.
1. Deep blue
2. Blue
3. Green
4. Yellow
5. Red
6. Purple

1 2 3 4 5 6

Representation of Newton´s experiment: a beam of light passes through a triangular prism and breaks up into the six primary and secondary colors of the spectrum.

Absorption and Reflection of Light

White light is composed of the light of six colors. Some objects reflect all the light they receive, while others absorb some or all of it. Most objects reflect or absorb part of the light and reflect the rest. This law of physics can be summarized thus: *All opaque objects, when they are illuminated, have the material qualities necessary to reflect all or part of the light they receive.* Thus…

• Depending on weather conditions, the sea absorbs all of the red and most of the yellow, while reflecting all of the blue and some of the yellow, producing this way the color we associate with water.

• Snow does not absorb any color; it reflects all of them, which, mixed together, produce white.

• Coal absorbs all colors and reflects none; the result is a total absence of color, that is to say, black.

Absorptions and reflections of light from objects:
1. Gray objects absorb and reflect equal amounts of red, green, and blue. 2. Yellow objects absorb all of the red and blue. 3. White objects reflect all colors. 4. A magenta object reflects red and a small amount of blue. 5. Black objects absorb all colors. 6. A blue surface absorbs all of the red and yellow.

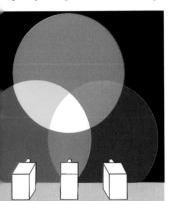

Representation of Young´s experiment.

LIGHT COLORS AND PIGMENT COLORS

Light Colors

Visible light colors are found in the part of the white light electromagnetic spectrum between 400 and 760 nanometers. (A nanometer is one billionth of a meter.) In the upper limits of this range lie infrared light and at the bottom, ultraviolet.

The different sources of illumination have varying chromatic tendencies, that is, they have different wavelengths. Even the color of sunlight varies significantly throughout the day.

Light color is cast by means of rays that imitate the effects of light itself. If a particular light color (green, for instance) is added to another color (red, for instance) a brighter color is obtained (yellow, in this case).

When light "paints" an object, it does so by adding different colored rays of light. When light creates a dark object it does so by adding more light (in other words, with rays of light of other colors). One must bear in mind that these laboratory demonstrations only apply to light project-

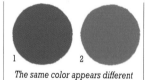

The same color appears different depending on whether it is (1) opaque or (2) transparent

ed in its pure translucent form, not to paints applied to an opaque surface.

Pigment Colors

Pigments are colors in solid form that are derived from various mineral and chemical sources, and when mixed with a liquid medium become paint. When used translucently, such as in watercolor, inks, or dyes, the surface showing through beneath the paint acts as another color.

In principle, all of the colors of nature can be obtained by mixing the three primary colors (yellow, red, and blue) in an

infinite variety of proportions. In practice, it is only possible to obtain 95% of the colors that occur in nature.

Complex and time consuming color mixing is often necessary in order to achieve certain desired tones. Therefore, the artists, graphic designers, and illustrators should take advantage of the numerous variety of colors now on the market.

In fact, in the traditional painting mediums, the three primary colors are rarely available. Artist's colors are manufactured with natural and synthetic pigments and come in a wide variety of tones which are displayed on accompanying color charts.

When dealing with pure pigment colors, it is important to bear in mind their *permanence* (color stability), their *solidity* (color not easily changed), and their *resistance to light* (how easily they fade or change color when exposed to light).

The result of mixing light colors together.
• White is the result of superimposing the three beams of light, green, red, and blue, the primary light colors.
• The projection of two of these colors produces the secondary light colors: yellow (the result of superimposing green and red), magenta (the result of superimposing red and intense blue) and cyan blue (the result of superimposing intense blue and green).

The result of mixing pigment colors together.
• Black is the result of superimposing the three primary colors: yellow, red, and blue.
• Mixing yellow and red together produces vermilion.
• Red plus blue gives us violet.
• By combining blue with yellow we get green.

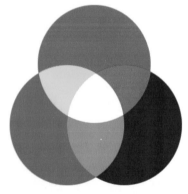

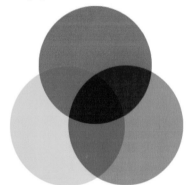

PRIMARY, SECONDARY, AND TERTIARY COLORS

Primary Colors

Primary colors are those that are not the result of mixing colors. When mixed together in varying quantities, the three primary colors can produce an almost infinite number of different colors. The three primary color pigments are yellow, red, and blue.

Scientifically speaking, the primary colors available to the artist may not exactly match the primary pigment colors mentioned above; in fact, they rarely do. However, in spite of the slight differences between the artist's primary colors and the laboratory ones, they are capable of producing the same results when mixed.

Secondary Colors

The colors produced by mixing two adjacent primary colors together are known as secondary colors. The following secondary colors are the result of very specific mixes of primaries:
- Violet (red + blue).
- Orange (yellow + red).
- Green (blue + yellow).

To obtain a pure secondary color it is necessary to use equal parts of each of the primary colors.

It is possible to obtain perfect secondary colors with covering (opaque) pigment colors.

Most paint manufacturers do not offer either primary or secondary colors in their pure form. Therefore, the artist, when mixing paint, can only approximate what the primary and secondary colors are.

The three pigment colors: yellow, red, and blue.

Tertiary Colors

Tertiary colors are, as the name implies, the third category on the color wheel. They are located between each of the primary and secondary colors. Each tertiary is obtained with the mix of a primary color and the closest secondary color. Thus, a tertiary color is a secondary color whose composition consists of one third primary color and two thirds of another one. As you can seen in the illustration at the bottom, there are six tertiary colors.

Secondary colors are obtained by mixing the primary colors with their neighbors on the color wheel. The mixing of red and yellow produces orange. The mixing of blue and yellow creates green. The mixing of blue and red produces violet.

Color wheel with the position of the primary colors (P), secondary colors (S), and tertiary colors (T).

A series of mixes involving primary and secondary colors thus producing tertiary colors.

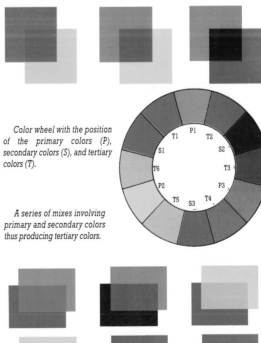

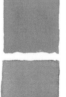

WARM, COOL, AND NEUTRAL COLORS

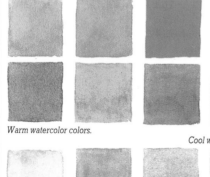

Warm watercolor colors.

Cool watercolor colors.

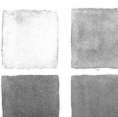

Neutral watercolor colors.

Cool Colors

These comprise all those colors that produce a feeling of coldness and distance, such as blue, bluish-green, and gray. These colors are employed in subjects such as snowscapes, seascapes, and night scenes. They also are used to achieve an illusion of distance, be it far off mountains or the sky. Cool colors are also necessary in creating certain pictorial dramatic moods, such as romance, mystery fantasy, and quietude.

Neutral Colors

Colors are neutralized by being mixed with their complements, that is, the colors directly opposite them on the color wheel. For example, red and green: depending on the proportions of the mix, one or the other color will have its intensity reduced and take on a grayish tone. As the result of neutralizing a color the unpleasant optical vibrations sometimes created by juxtaposing certain colors is avoided. In addition, when a color is neutralized, it will function in harmony with all other colors. One interesting result of mixing across the color wheel is that if you combine the three primary colors in equal proportion you will arrive at the color black. Neutral colors, often called broken colors by painters, tend to be used in paintings to balance saturated and intense tones. In certain pictorial schools, artists have monopolized neutral colors thanks to the almost limitless harmonic subtleties that can be achieved with them.

Warm Colors

Psychologically speaking, warm colors are associated with heat and closeness. Examples of warm colors are reds and yellows, plus their tertiary and, sometimes, their secondary colors. A color ceases to be warm when blue begins to dominate in a mix. However, a blue green may appear to be warm when placed next to a pure blue. Color temperature is frequently a matter of relationship. Also, the way in which we see or "feel" a color is often conditioned by visual associations such as blue with winter, yellow with the sun, red with blood and violence, orange with fire, green with growth, violet with mystery, black with death, and white with purity.

The possibility of broken color clashes is far more reduced than among saturated tones due to the wideness of their range.

Range of warm colors. *Range of cool colors.* *Range of neutral colors.*

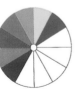

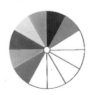

Warm, Cool, and Neutral Colors
General Notes. Instructions
Lemon Yellow

9

GENERAL NOTES. INSTRUCTIONS

General Observations

• Artists paint with pigments that reproduce the same colors as light.

• Given that the colors of light coincide with those on the palette, it is possible for the painter to reproduce the effects of light on all aspects of nature and therefore capture reality through color.

• The theory of color and light demonstrates that the artist can reproduce all the colors of nature using only the three primary colors: yellow, blue, and red.

• A working knowledge of complementary colors offers the artist an endless range of tonal possibilities as well as the means to achieve an overall harmony in a painting.

• Although there is agreement about the names of basic colors, when we speak of different tonalities, we find that the names can vary greatly.

• The purchase of a specific color is no guarantee of obtaining what one is accustomed to. The colors of some brands are more opaque or more transparent, or are more or less intense than the same colors found in other brands. Therefore, it is up to each painter to settle on which ones best suit his or her needs. The emerald green of one brand may be brighter than that of another. In such cases a painter might choose to work with colors of various brands.

• In order to fully understand the use of color it is essential that you obtain a color wheel, which can be purchased inexpensively, at any art materials store.

• The value of the color wheel is that it shows, in simple terms, the relationships of all colors to one another in a way that corresponds visually to the actual needs of an artist and his or her palette.

• A color wheel can be described as follows: imagine a circle on which at three equal points are placed the primary colors, red, yellow, and blue. Half way between the primaries are the three secondary colors, orange, green, and violet. Between each primary and secondary color is a tertiary color, red orange, yellow orange, yellow green, etc. Beginning with the primaries, all of these colors are obtained through a 50-50 mix of adjacent colors.

• Perhaps the major advantage of the color wheel is as a guide to color relationships. This is accomplished by running a line from any color though the center of the circle to its opposite or complementary color. It is through the mixing of a color with its complement that we neutralize a color, that is, reduce its chromatic brilliance in order to allow it to better harmonize with other colors. The "secret" of this harmony lies in the fact that all complementary color mixes contain some of all three of the primaries.

Complementary pigment color pairs

Instructions for Using the Charts

• Only six colors have been used to create the mixes presented in this book: the three primary colors and the three secondaries, whose equivalents are noted below:

A. Yellow Pantone: Process Yellow (Lemon Yellow)
B. Red (magenta) Pantone: Process Magenta (Permanent Rose)
C. (Cyan) blue Pantone: Process Cyan (Cerulean Blue)
D. Orange Pantone: Orange 021U (Cadmium Orange)
E. Violet Pantone: Blue 072U (Violet)
F. Dark green Pantone: 366U (Permanent Green)

The above color codes are standard internationally.

• The graph shows the amount required in the mix and each letter corresponds to the color assigned.

• The numbers (10, 20, 30,...100) on the horizontal line indicate the proportions, up to ten parts, that are required in each mix to achieve the desired color.

• The color bar indicates the quantity of color needed in the mix.

• The number that appears at the end of each bar indicates the exact quantity of the color used.

• The color swatches correspond to the result obtained by our artist applying the quantity of colors prescribed to obtain the color. The reliability of each tone has been checked by computer.

• The names used in the color charts are the ones most commonly accepted. No international norms or lexicons have been used since they do not exist.

PRIMARY COLORS
YELLOW + MAGENTA

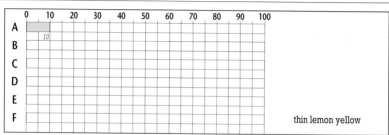

thin lemon yellow

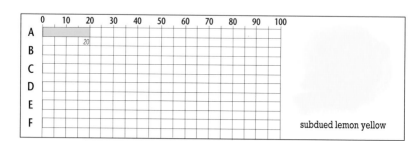

subdued lemon yellow

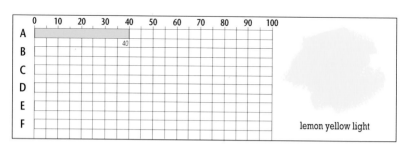

transparent lemon yellow

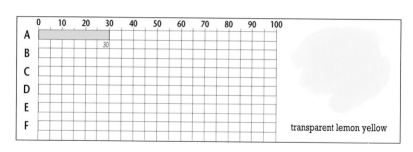

lemon yellow light

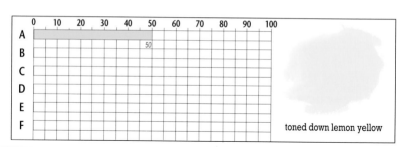

toned down lemon yellow

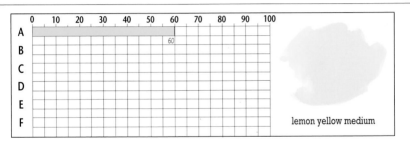

lemon yellow medium

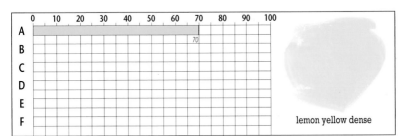

lemon yellow dense

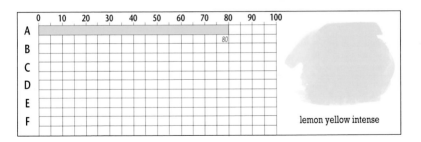

lemon yellow intense

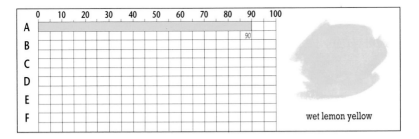

wet lemon yellow

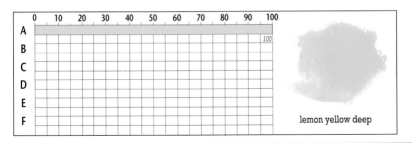

lemon yellow deep

PRIMARY COLORS
YELLOW + MAGENTA

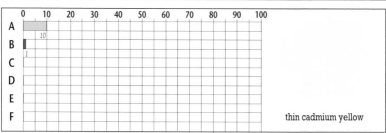

thin cadmium yellow

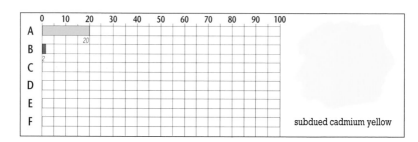

subdued cadmium yellow

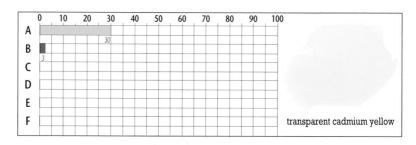

transparent cadmium yellow

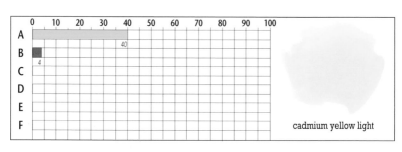

cadmium yellow light

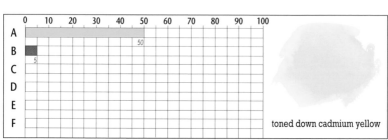

toned down cadmium yellow

Warm, Cool, and Neutral Colors
General Notes. Instructions
Lemon Yellow

9

GENERAL NOTES. INSTRUCTIONS

General Observations

• Artists paint with pigments that reproduce the same colors as light.

• Given that the colors of light coincide with those on the palette, it is possible for the painter to reproduce the effects of light on all aspects of nature and therefore capture reality through color.

• The theory of color and light demonstrates that the artist can reproduce all the colors of nature using only the three primary colors: yellow, blue, and red.

• A working knowledge of complementary colors offers the artist an endless range of tonal possibilities as well as the means to achieve an overall harmony in a painting.

• Although there is agreement about the names of basic colors, when we speak of different tonalities, we find that the names can vary greatly.

• The purchase of a specific color is no guarantee of obtaining what one is accustomed to. The colors of some brands are more opaque or more transparent, or are more or less intense than the same colors found in other brands. Therefore, it is up to each painter to settle on which ones best suit his or her needs. The emerald green of one brand may be brighter than that of another. In such cases a painter might choose to work with colors of various brands.

• In order to fully understand the use of color it is essential that you obtain a color wheel, which can be purchased inexpensively, at any art materials store.

• The value of the color wheel is that it shows, in simple terms, the relationships of all colors to one another in a way that corresponds visually to the actual needs of an artist and his or her palette.

• A color wheel can be described as follows: imagine a circle on which at three equal points are placed the primary colors, red, yellow, and blue. Half way between the primaries are the three secondary colors, orange, green, and violet. Between each primary and secondary color is a tertiary color, red orange, yellow orange, yellow green, etc. Beginning with the primaries, all of these colors are obtained through a 50-50 mix of adjacent colors.

• Perhaps the major advantage of the color wheel is as a guide to color relationships. This is accomplished by running a line from any color though the center of the circle to its opposite or complementary color. It is through the mixing of a color with its complement that we neutralize a color, that is, reduce its chromatic brilliance in order to allow it to better harmonize with other colors. The "secret" of this harmony lies in the fact that all complementary color mixes contain some of all three of the primaries.

Complementary pigment color pairs

Instructions for Using the Charts

• Only six colors have been used to create the mixes presented in this book: the three primary colors and the three secondaries, whose equivalents are noted below:

A. Yellow — Pantone: Process Yellow (Lemon Yellow)
B. Red (magenta) — Pantone: Process Magenta (Permanent Rose)
C. (Cyan) blue — Pantone: Process Cyan (Cerulean Blue)
D. Orange — Pantone: Orange 021U (Cadmium Orange)
E. Violet — Pantone: Blue 072U (Violet)
F. Dark green — Pantone: 366U (Permanent Green)

The above color codes are standard internationally.

• The graph shows the amount required in the mix and each letter corresponds to the color assigned.

• The numbers (10, 20, 30,...100) on the horizontal line indicate the proportions, up to ten parts, that are required in each mix to achieve the desired color.

• The color bar indicates the quantity of color needed in the mix.

• The number that appears at the end of each bar indicates the exact quantity of the color used.

• The color swatches correspond to the result obtained by our artist applying the quantity of colors prescribed to obtain the color. The reliability of each tone has been checked by computer.

• The names used in the color charts are the ones most commonly accepted. No international norms or lexicons have been used since they do not exist.

PRIMARY COLORS
YELLOW + MAGENTA

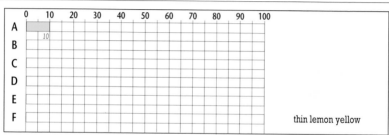

thin lemon yellow

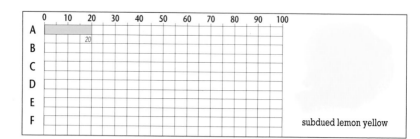

subdued lemon yellow

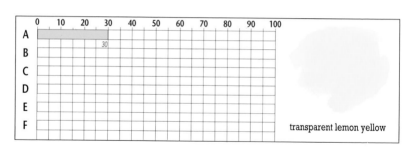

transparent lemon yellow

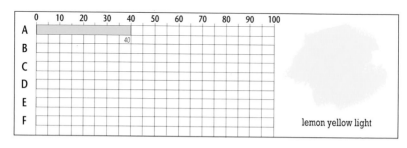

lemon yellow light

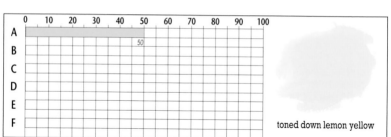

toned down lemon yellow

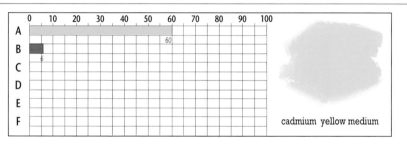

cadmium yellow medium

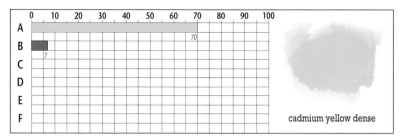

cadmium yellow dense

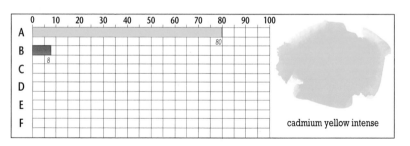

cadmium yellow intense

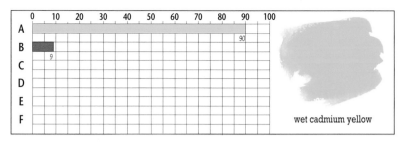

wet cadmium yellow

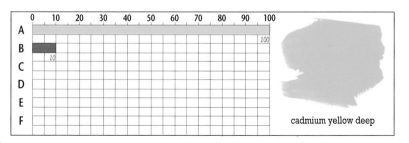

cadmium yellow deep

PRIMARY COLORS
YELLOW + MAGENTA

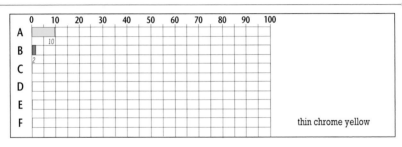

	0	10	20	30	40	50	60	70	80	90	100
A		10									
B	2										
C											
D											
E											
F											

thin chrome yellow

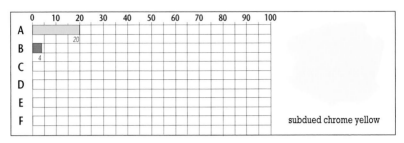

	0	10	20	30	40	50	60	70	80	90	100
A			20								
B	4										
C											
D											
E											
F											

subdued chrome yellow

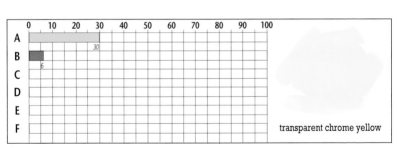

	0	10	20	30	40	50	60	70	80	90	100
A				30							
B	6										
C											
D											
E											
F											

transparent chrome yellow

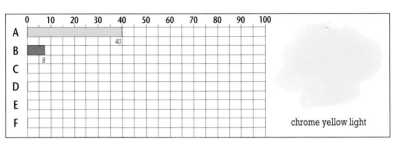

	0	10	20	30	40	50	60	70	80	90	100
A					40						
B	8										
C											
D											
E											
F											

chrome yellow light

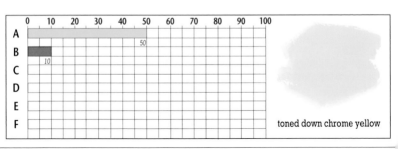

	0	10	20	30	40	50	60	70	80	90	100
A						50					
B	10										
C											
D											
E											
F											

toned down chrome yellow

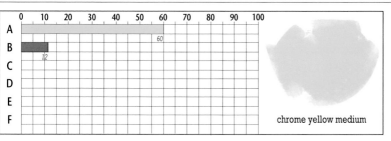

chrome yellow medium

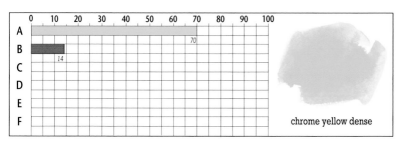

chrome yellow dense

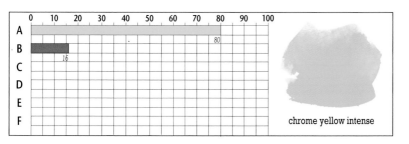

chrome yellow intense

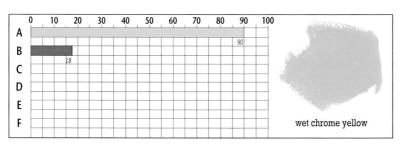

wet chrome yellow

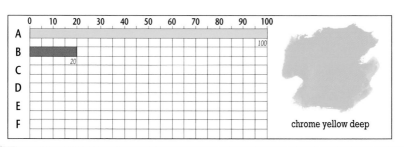

chrome yellow deep

PRIMARY COLORS
YELLOW + MAGENTA

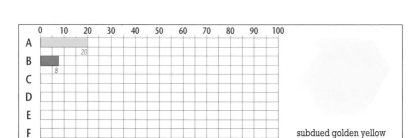

thin golden yellow

subdued golden yellow

transparent golden yellow

golden yellow light

toned down golden yellow

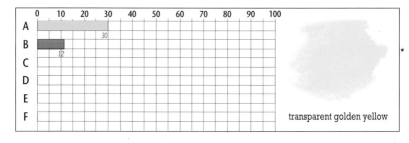

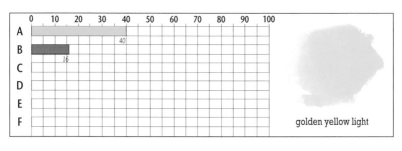

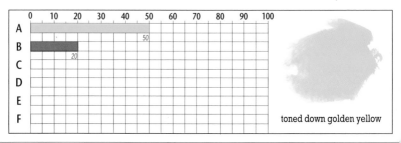

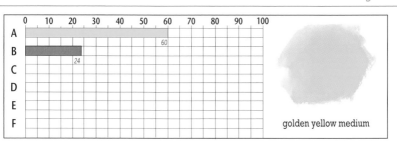

golden yellow medium

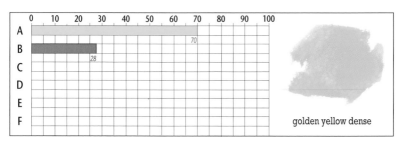

golden yellow dense

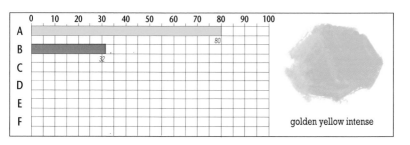

golden yellow intense

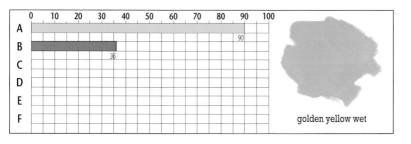

golden yellow wet

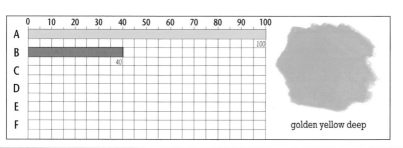

golden yellow deep

PRIMARY COLORS
YELLOW + MAGENTA

	0	10	20	30	40	50	60	70	80	90	100
A	10										
B	6										
C											
D											
E											
F											

thin brilliant orange

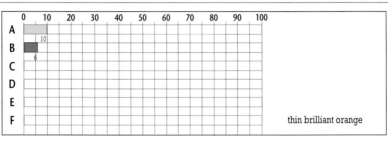

	0	10	20	30	40	50	60	70	80	90	100
A			20								
B		12									
C											
D											
E											
F											

subdued brilliant orange

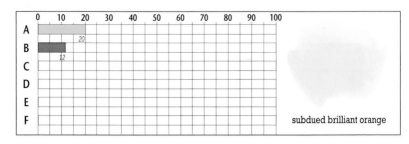

	0	10	20	30	40	50	60	70	80	90	100
A				30							
B			18								
C											
D											
E											
F											

transparent brilliant orange

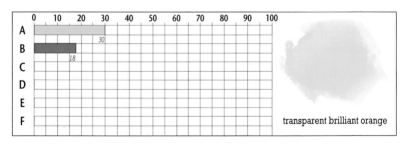

	0	10	20	30	40	50	60	70	80	90	100
A					40						
B			24								
C											
D											
E											
F											

brilliant orange light

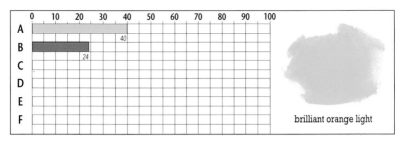

	0	10	20	30	40	50	60	70	80	90	100
A						50					
B				30							
C											
D											
E											
F											

toned down brilliant orange

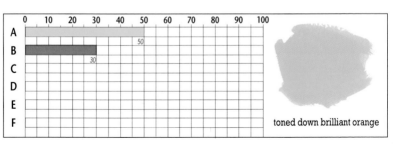

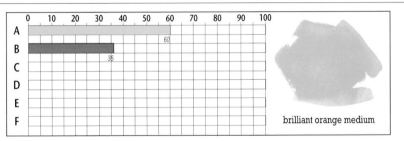

brilliant orange medium

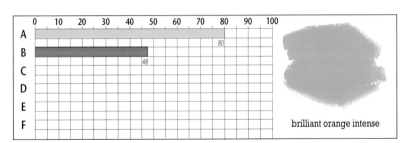

brilliant orange dense

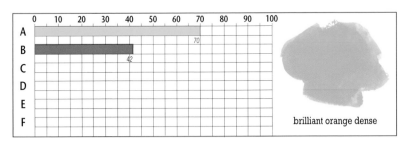

brilliant orange intense

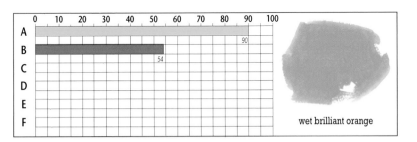

wet brilliant orange

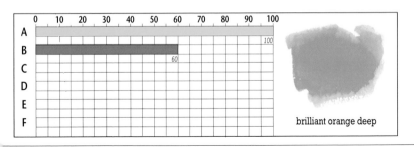

brilliant orange deep

PRIMARY COLORS
YELLOW + MAGENTA

	0	10	20	30	40	50	60	70	80	90	100
A	10										
B	8										
C											
D											
E											
F											

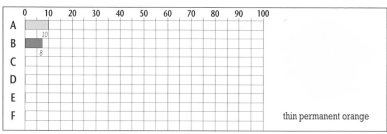

thin permanent orange

	0	10	20	30	40	50	60	70	80	90	100
A			20								
B		16									
C											
D											
E											
F											

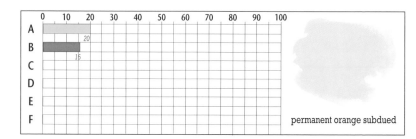

permanent orange subdued

	0	10	20	30	40	50	60	70	80	90	100
A				30							
B			24								
C											
D											
E											
F											

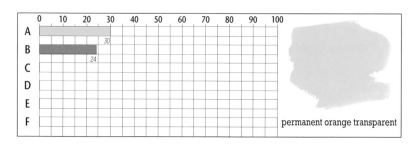

permanent orange transparent

	0	10	20	30	40	50	60	70	80	90	100
A					40						
B				32							
C											
D											
E											
F											

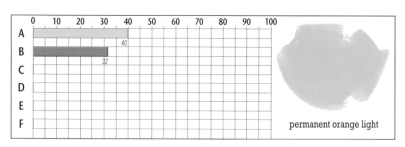

permanent orange light

	0	10	20	30	40	50	60	70	80	90	100
A						50					
B					40						
C											
D											
E											
F											

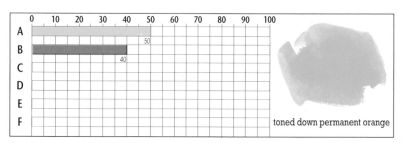

toned down permanent orange

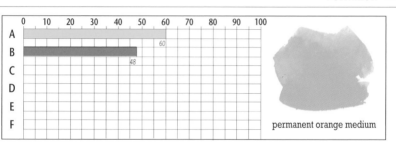

	0	10	20	30	40	50	60	70	80	90	100
A							60				
B					48						
C											
D											
E											
F											

permanent orange medium

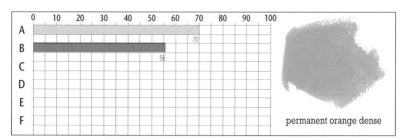

	0	10	20	30	40	50	60	70	80	90	100
A								70			
B						56					
C											
D											
E											
F											

permanent orange dense

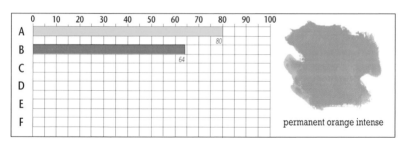

	0	10	20	30	40	50	60	70	80	90	100
A									80		
B							64				
C											
D											
E											
F											

permanent orange intense

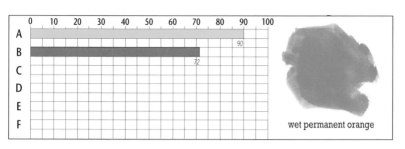

	0	10	20	30	40	50	60	70	80	90	100
A										90	
B								72			
C											
D											
E											
F											

wet permanent orange

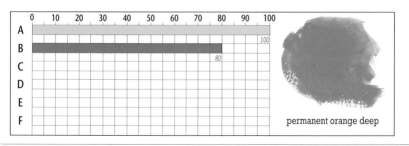

	0	10	20	30	40	50	60	70	80	90	100
A											100
B									80		
C											
D											
E											
F											

permanent orange deep

PRIMARY COLORS:
YELLOW + MAGENTA

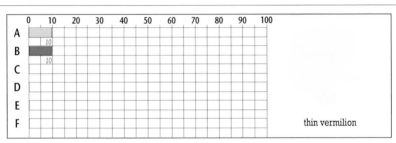

	0	10	20	30	40	50	60	70	80	90	100
A		10									
B	10										
C											
D											
E											
F											

thin vermilion

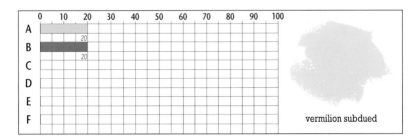

	0	10	20	30	40	50	60	70	80	90	100
A			20								
B		20									
C											
D											
E											
F											

vermilion subdued

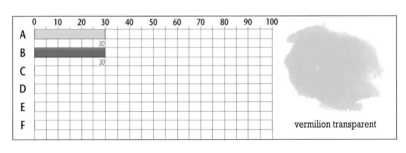

	0	10	20	30	40	50	60	70	80	90	100
A			30								
B			30								
C											
D											
E											
F											

vermilion transparent

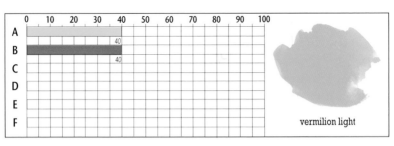

	0	10	20	30	40	50	60	70	80	90	100
A				40							
B				40							
C											
D											
E											
F											

vermilion light

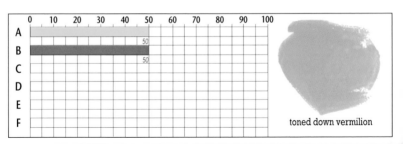

	0	10	20	30	40	50	60	70	80	90	100
A					50						
B					50						
C											
D											
E											
F											

toned down vermilion

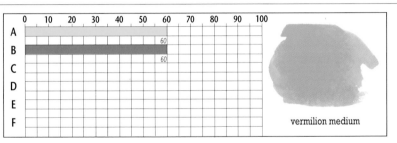

	0	10	20	30	40	50	60	70	80	90	100
A							60				
B							60				
C											
D											
E											
F											

vermilion medium

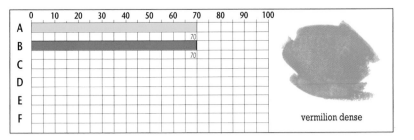

	0	10	20	30	40	50	60	70	80	90	100
A								70			
B								70			
C											
D											
E											
F											

vermilion dense

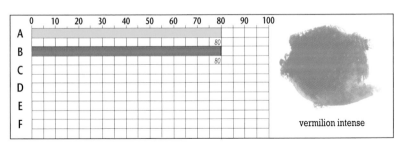

	0	10	20	30	40	50	60	70	80	90	100
A									80		
B									80		
C											
D											
E											
F											

vermilion intense

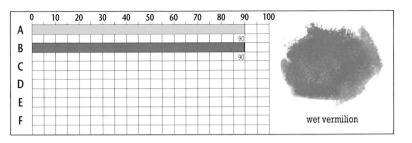

	0	10	20	30	40	50	60	70	80	90	100
A										90	
B										90	
C											
D											
E											
F											

wet vermilion

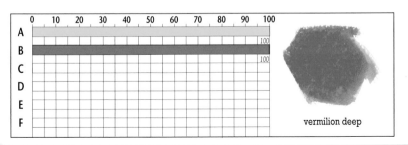

	0	10	20	30	40	50	60	70	80	90	100
A											100
B											100
C											
D											
E											
F											

vermilion deep

PRIMARY COLORS
MAGENTA + BLUE

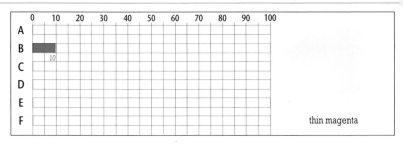

thin magenta

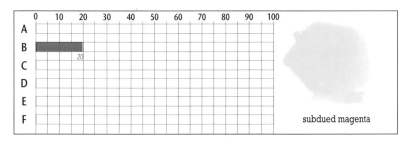

subdued magenta

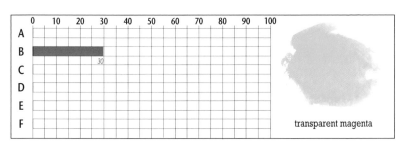

transparent magenta

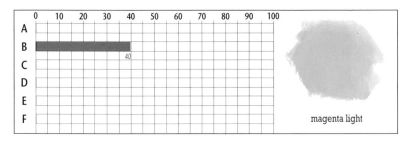

magenta light

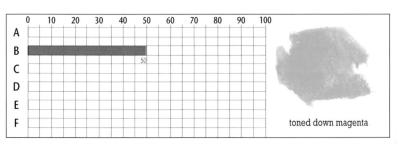

toned down magenta

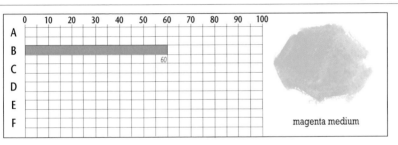

	0	10	20	30	40	50	60	70	80	90	100
A											
B							60				
C											
D											
E											
F											

magenta medium

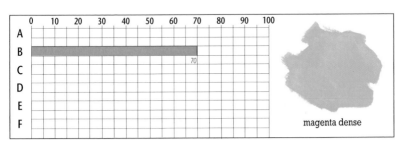

	0	10	20	30	40	50	60	70	80	90	100
A											
B								70			
C											
D											
E											
F											

magenta dense

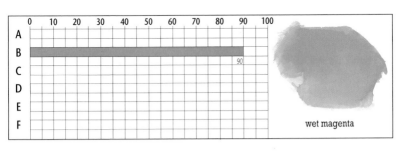

	0	10	20	30	40	50	60	70	80	90	100
A											
B									80		
C											
D											
E											
F											

magenta intense

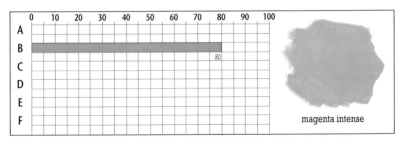

	0	10	20	30	40	50	60	70	80	90	100
A											
B										90	
C											
D											
E											
F											

wet magenta

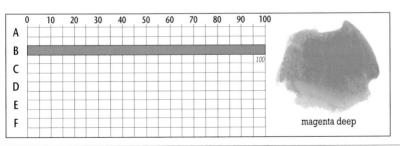

	0	10	20	30	40	50	60	70	80	90	100
A											
B											100
C											
D											
E											
F											

magenta deep

PRIMARY COLORS
MAGENTA + BLUE

	0	10	20	30	40	50	60	70	80	90	100
A											
B	10										
C	1										
D											
E											
F											

thin purple

	0	10	20	30	40	50	60	70	80	90	100
A											
B		20									
C	2										
D											
E											
F											

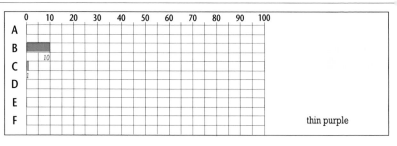

subdued purple

	0	10	20	30	40	50	60	70	80	90	100
A											
B			30								
C	3										
D											
E											
F											

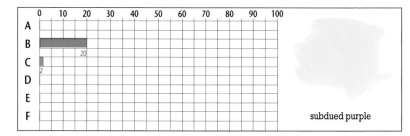

transparent purple

	0	10	20	30	40	50	60	70	80	90	100
A											
B				40							
C	4										
D											
E											
F											

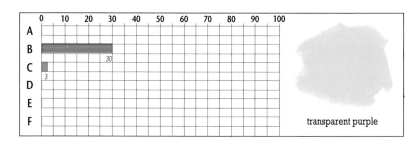

purple light

	0	10	20	30	40	50	60	70	80	90	100
A											
B					50						
C	5										
D											
E											
F											

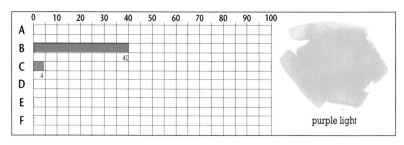

toned down purple

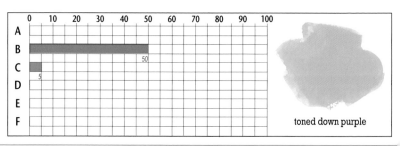

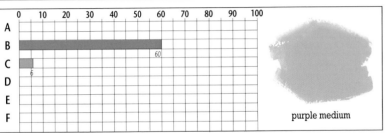

purple medium

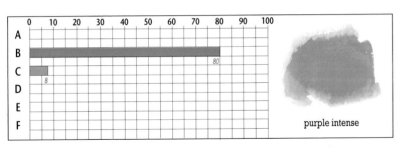

purple dense

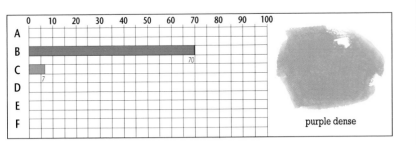

purple intense

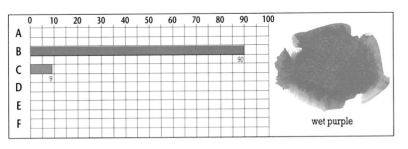

wet purple

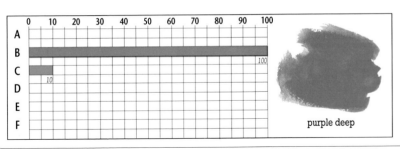

purple deep

PRIMARY COLORS
MAGENTA + BLUE

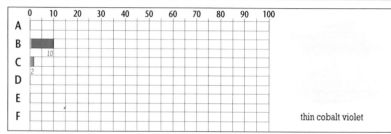

thin cobalt violet

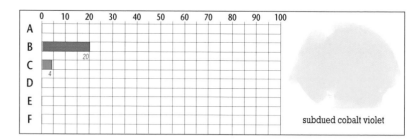

subdued cobalt violet

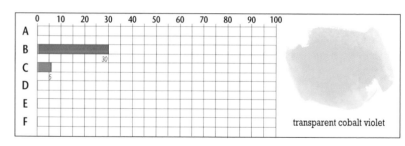

transparent cobalt violet

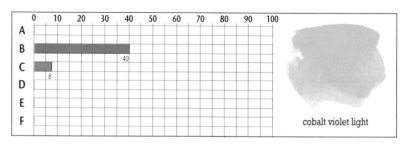

cobalt violet light

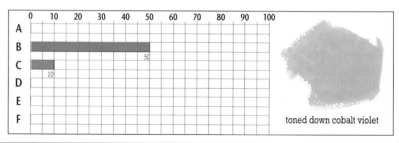

toned down cobalt violet

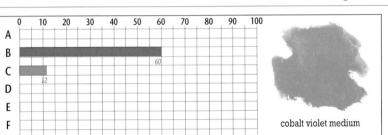

cobalt violet medium

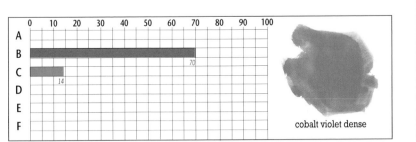

cobalt violet dense

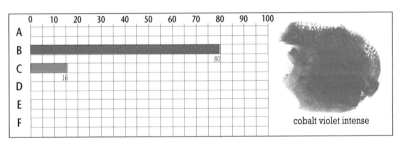

cobalt violet intense

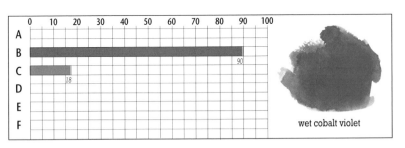

wet cobalt violet

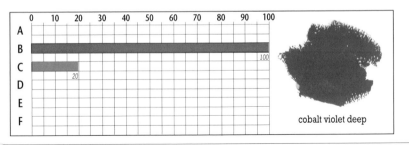

cobalt violet deep

PRIMARY COLORS
MAGENTA + BLUE

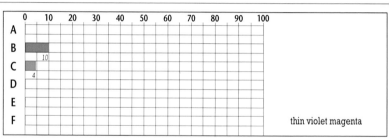

thin violet magenta

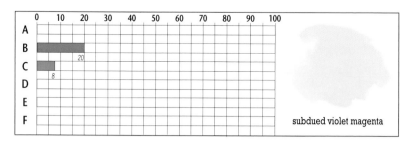

subdued violet magenta

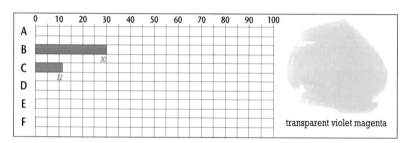

transparent violet magenta

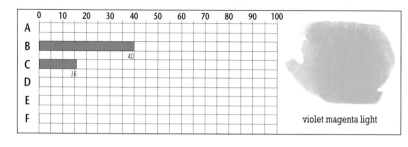

violet magenta light

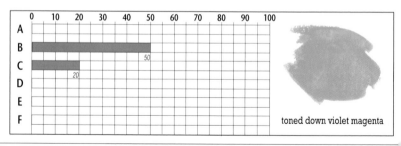

toned down violet magenta

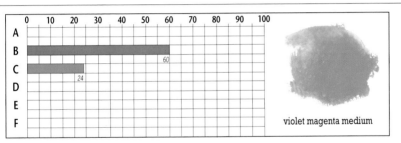

violet magenta medium

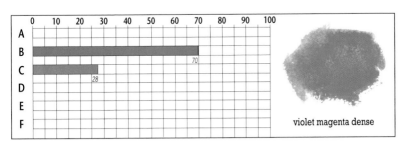

violet magenta dense

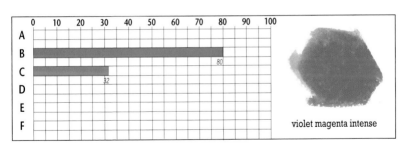

violet magenta intense

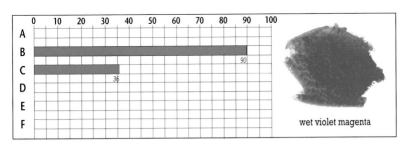

wet violet magenta

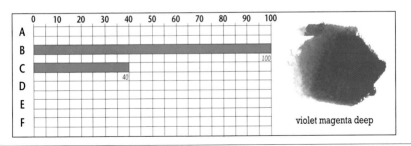

violet magenta deep

PRIMARY COLORS
MAGENTA + BLUE

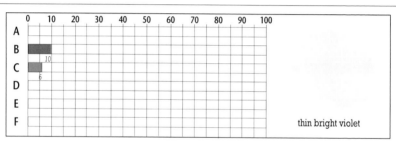

thin bright violet

(B: 10, C: 6)

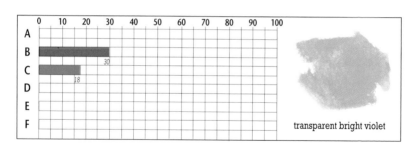

subdued bright violet

(B: 20, C: 12)

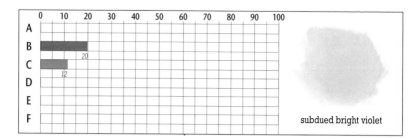

transparent bright violet

(B: 30, C: 18)

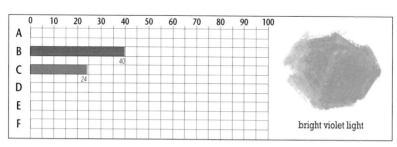

bright violet light

(B: 40, C: 24)

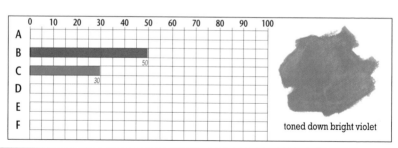

toned down bright violet

(B: 50, C: 30)

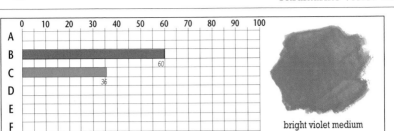

bright violet medium

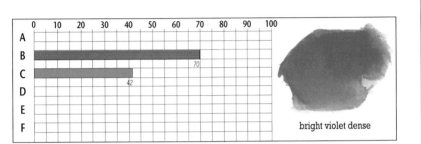

bright violet dense

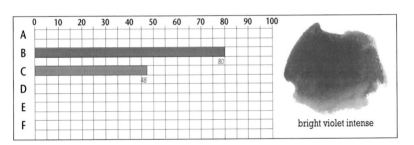

bright violet intense

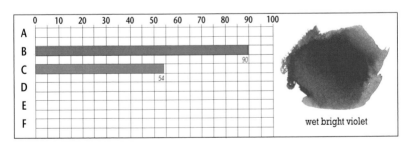

wet bright violet

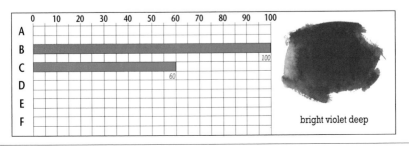

bright violet deep

PRIMARY COLORS
MAGENTA + BLUE

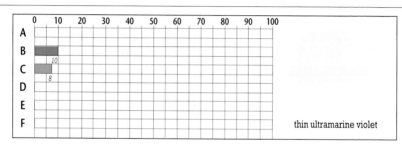

thin ultramarine violet

	0	10	20	30	40	50	60	70	80	90	100
A											
B											
C	10										
D	8										
E											
F											

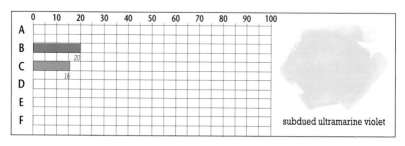

subdued ultramarine violet

	0	10	20	30	40	50	60	70	80	90	100
A											
B			20								
C		16									
D											
E											
F											

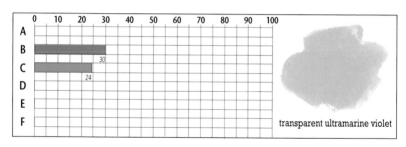

transparent ultramarine violet

	0	10	20	30	40	50	60	70	80	90	100
A											
B				30							
C			24								
D											
E											
F											

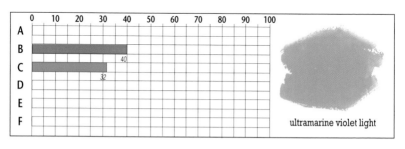

ultramarine violet light

	0	10	20	30	40	50	60	70	80	90	100
A											
B					40						
C				32							
D											
E											
F											

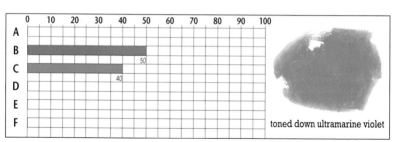

toned down ultramarine violet

	0	10	20	30	40	50	60	70	80	90	100
A											
B						50					
C					40						
D											
E											
F											

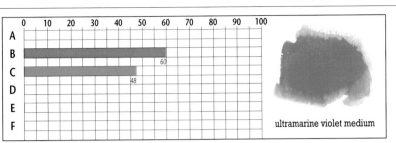

	0	10	20	30	40	50	60	70	80	90	100
A											
B							60				
C					48						
D											
E											
F											

ultramarine violet medium

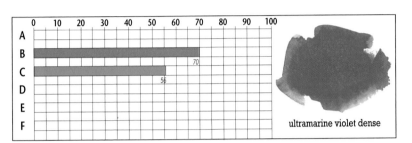

	0	10	20	30	40	50	60	70	80	90	100
A											
B								70			
C						56					
D											
E											
F											

ultramarine violet dense

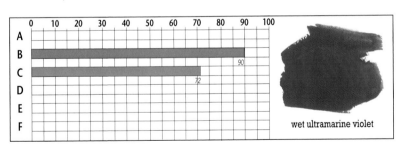

	0	10	20	30	40	50	60	70	80	90	100
A											
B									80		
C							64				
D											
E											
F											

ultramarine violet intense

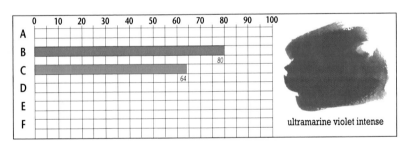

	0	10	20	30	40	50	60	70	80	90	100
A											
B										90	
C								72			
D											
E											
F											

wet ultramarine violet

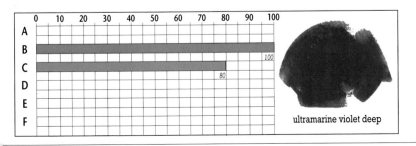

	0	10	20	30	40	50	60	70	80	90	100
A											
B											100
C									80		
D											
E											
F											

ultramarine violet deep

PRIMARY COLORS
MAGENTA + BLUE

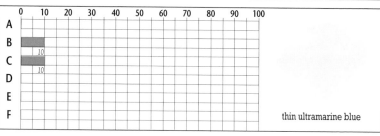

thin ultramarine blue

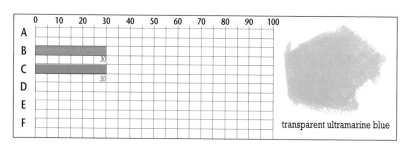

subdued ultramarine blue

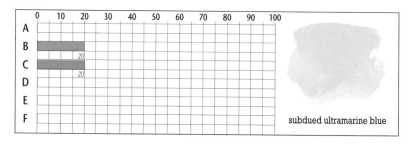

transparent ultramarine blue

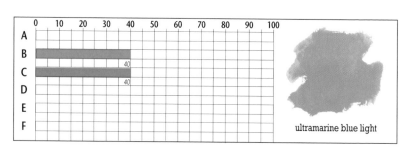

ultramarine blue light

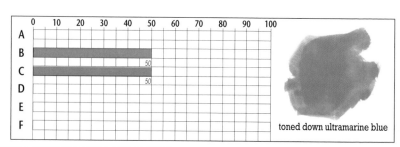

toned down ultramarine blue

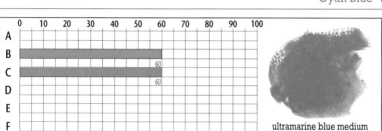

ultramarine blue medium

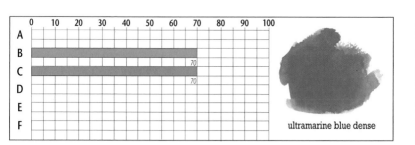

ultramarine blue dense

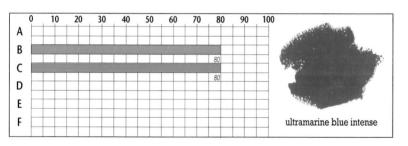

ultramarine blue intense

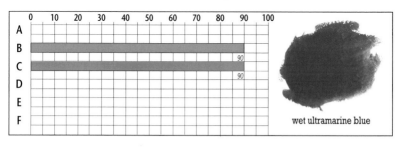

wet ultramarine blue

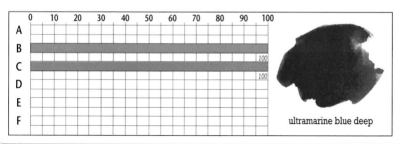

ultramarine blue deep

PRIMARY COLORS:
BLUE + YELLOW

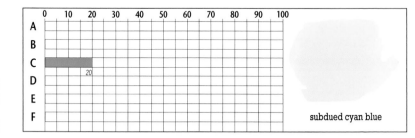

thin cyan blue

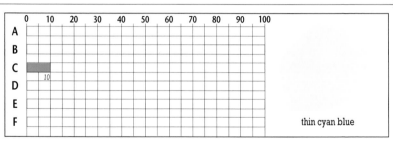

subdued cyan blue

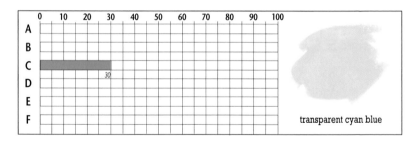

transparent cyan blue

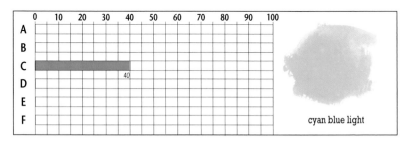

cyan blue light

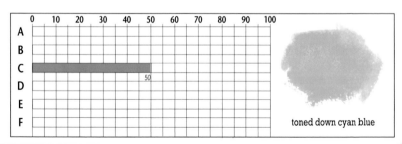

toned down cyan blue

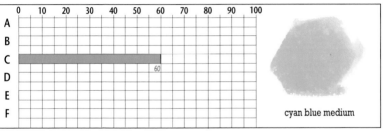

cyan blue medium

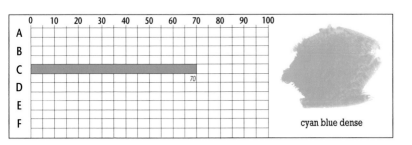

cyan blue dense

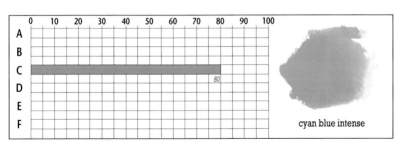

cyan blue intense

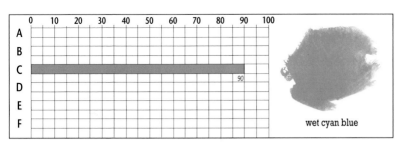

wet cyan blue

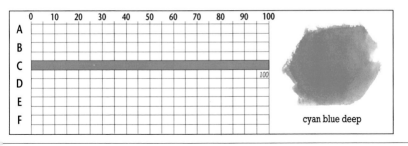

cyan blue deep

PRIMARY COLORS:
BLUE + YELLOW

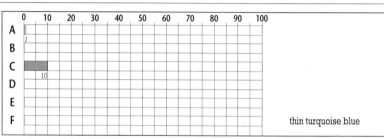

thin turquoise blue

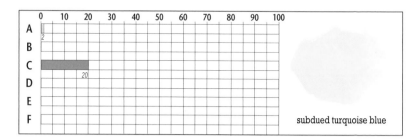

subdued turquoise blue

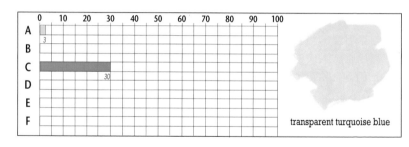

transparent turquoise blue

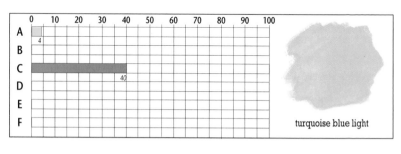

turquoise blue light

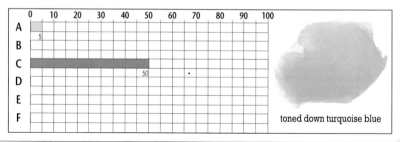

toned down turquoise blue

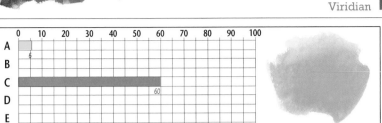

	0	10	20	30	40	50	60	70	80	90	100		
A	6												
B													
C							60						
D													
E													
F													

turquoise blue medium

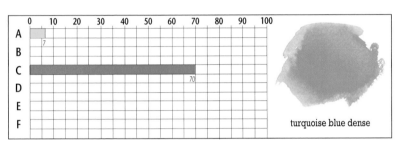

	0	10	20	30	40	50	60	70	80	90	100		
A	7												
B													
C								70					
D													
E													
F													

turquoise blue dense

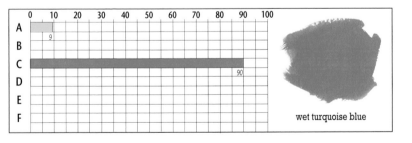

	0	10	20	30	40	50	60	70	80	90	100		
A	8												
B													
C									80				
D													
E													
F													

turquoise blue intense

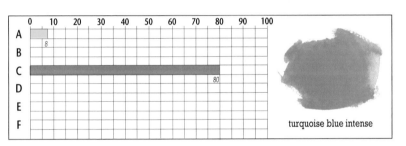

	0	10	20	30	40	50	60	70	80	90	100		
A	9												
B													
C										90			
D													
E													
F													

wet turquoise blue

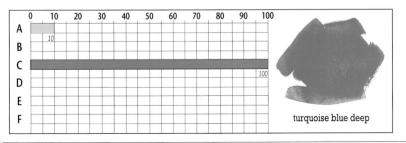

	0	10	20	30	40	50	60	70	80	90	100	
A	10											
B												
C											100	
D												
E												
F												

turquoise blue deep

PRIMARY COLORS:
BLUE + YELLOW

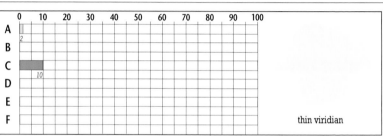

thin viridian

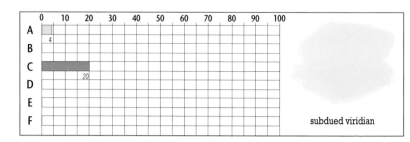

subdued viridian

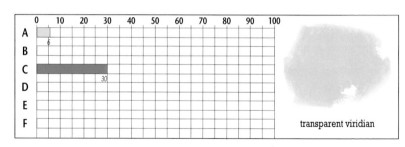

transparent viridian

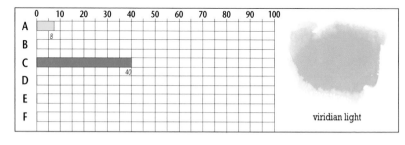

viridian light

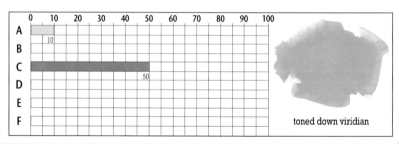

toned down viridian

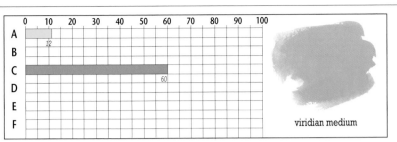

viridian medium

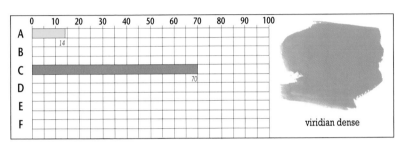

viridian dense

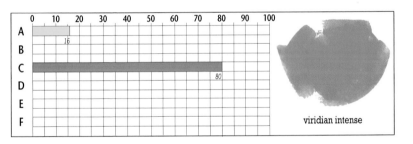

viridian intense

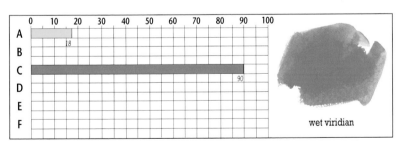

wet viridian

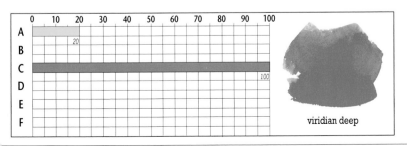

viridian deep

PRIMARY COLORS:
BLUE + YELLOW

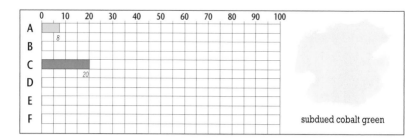

thin cobalt green

A 4
C 10

subdued cobalt green

A 8
C 20

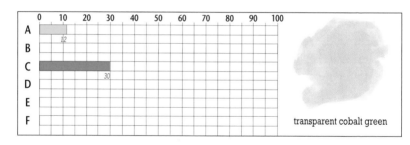

transparent cobalt green

A 12
C 30

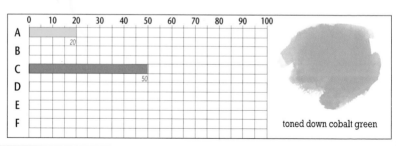

cobalt green light

A 16
C 40

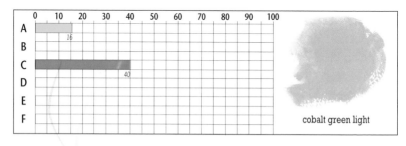

toned down cobalt green

A 20
C 50

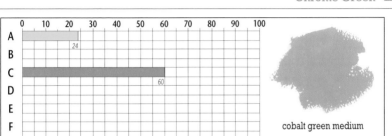

cobalt green medium

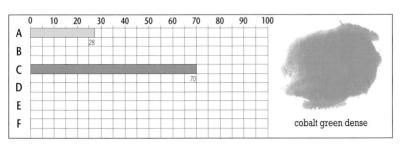

cobalt green dense

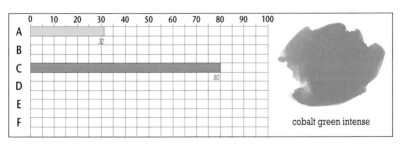

cobalt green intense

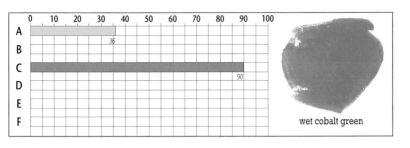

wet cobalt green

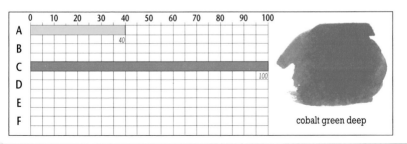

cobalt green deep

PRIMARY COLORS:
BLUE + YELLOW

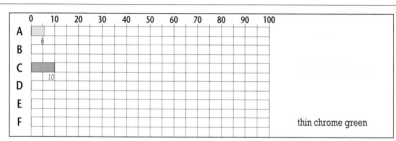

	0	10	20	30	40	50	60	70	80	90	100
A	6										
B											
C	10										
D											
E											
F											

thin chrome green

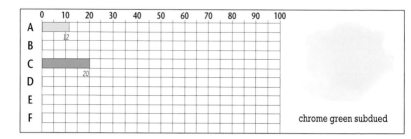

	0	10	20	30	40	50	60	70	80	90	100
A	12										
B											
C	20										
D											
E											
F											

chrome green subdued

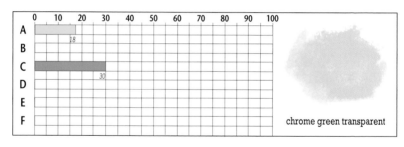

	0	10	20	30	40	50	60	70	80	90	100
A	18										
B											
C	30										
D											
E											
F											

chrome green transparent

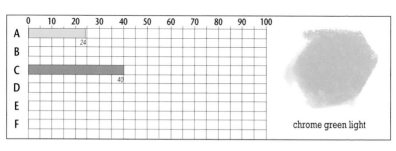

	0	10	20	30	40	50	60	70	80	90	100
A	24										
B											
C	40										
D											
E											
F											

chrome green light

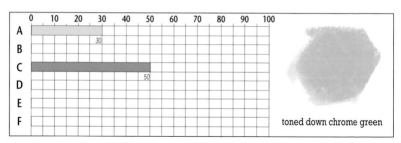

	0	10	20	30	40	50	60	70	80	90	100
A	30										
B											
C	50										
D											
E											
F											

toned down chrome green

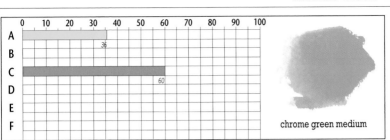

chrome green medium

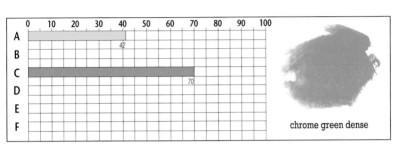

chrome green intense

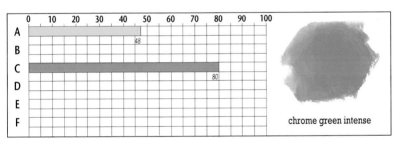

wet chrome green

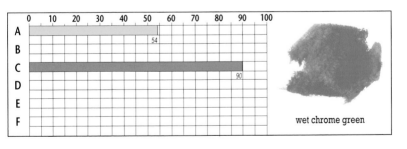

chrome green deep

PRIMARY COLORS:
BLUE + YELLOW

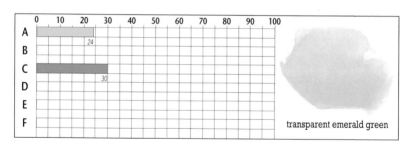

thin emerald green

subdued emerald green

transparent emerald green

emerald green light

toned down emerald green

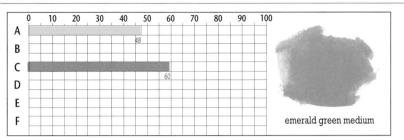

| | 0 | 10 | 20 | 30 | 40 | 50 | 60 | 70 | 80 | 90 | 100 |
A — 48
C — 60

emerald green medium

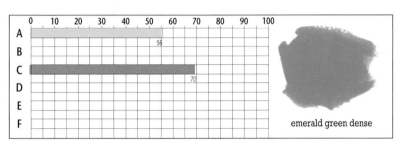

A — 56
C — 70

emerald green dense

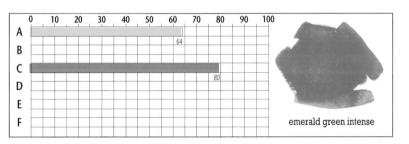

A — 64
C — 80

emerald green intense

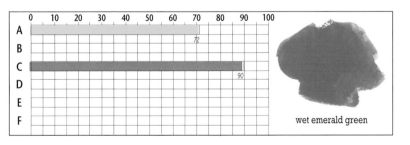

A — 72
C — 90

wet emerald green

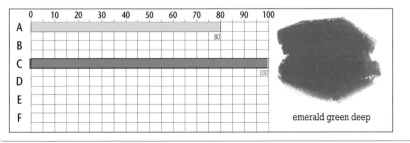

A — 80
C — 100

emerald green deep

PRIMARY COLORS:
BLUE + YELLOW

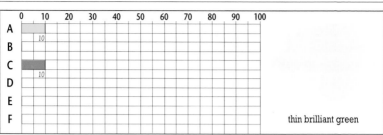

	0	10	20	30	40	50	60	70	80	90	100
A		10									
B											
C		10									
D											
E											
F											

thin brilliant green

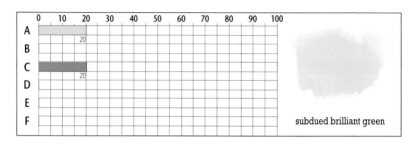

	0	10	20	30	40	50	60	70	80	90	100
A			20								
B											
C			20								
D											
E											
F											

subdued brilliant green

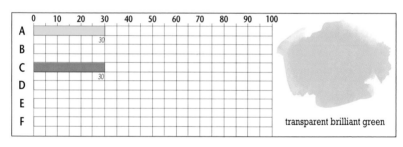

	0	10	20	30	40	50	60	70	80	90	100
A				30							
B											
C				30							
D											
E											
F											

transparent brilliant green

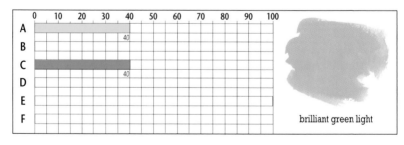

	0	10	20	30	40	50	60	70	80	90	100
A					40						
B											
C					40						
D											
E											
F											

brilliant green light

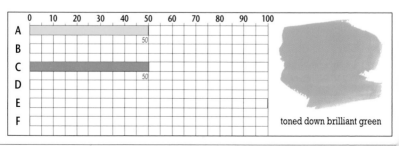

	0	10	20	30	40	50	60	70	80	90	100
A						50					
B											
C						50					
D											
E											
F											

toned down brilliant green

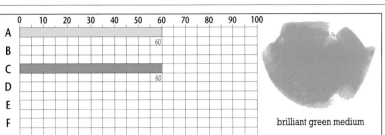

	0	10	20	30	40	50	60	70	80	90	100
A							60				
B											
C							60				
D											
E											
F											

brilliant green medium

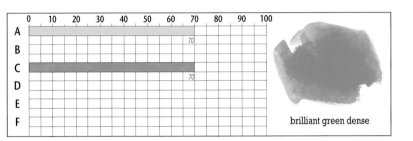

	0	10	20	30	40	50	60	70	80	90	100
A								70			
B											
C								70			
D											
E											
F											

brilliant green dense

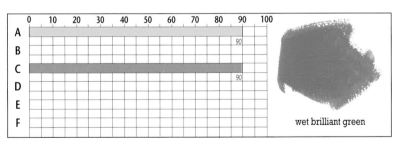

	0	10	20	30	40	50	60	70	80	90	100
A									80		
B											
C									80		
D											
E											
F											

brilliant green intense

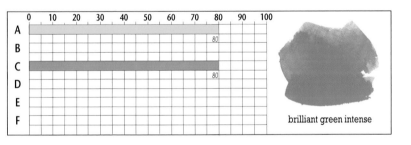

	0	10	20	30	40	50	60	70	80	90	100
A										90	
B											
C										90	
D											
E											
F											

wet brilliant green

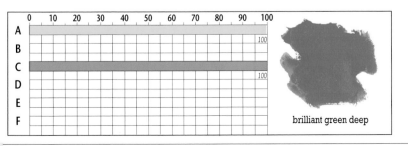

	0	10	20	30	40	50	60	70	80	90	100
A											100
B											
C											100
D											
E											
F											

brilliant green deep

SECONDARY COLORS:
ORANGE + VIOLET

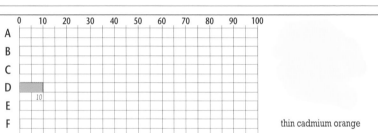

thin cadmium orange

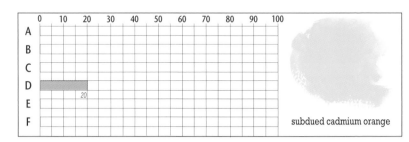

subdued cadmium orange

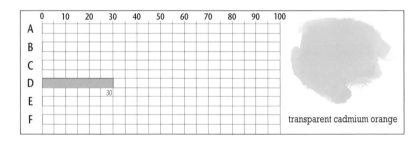

transparent cadmium orange

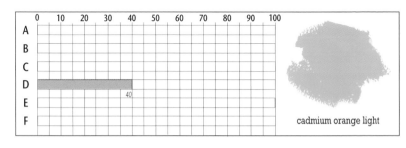

cadmium orange light

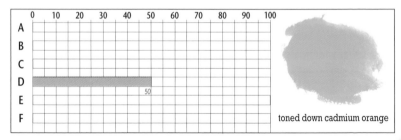

toned down cadmium orange

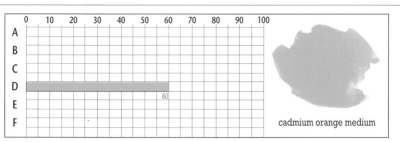

cadmium orange medium

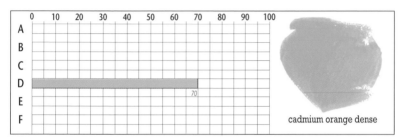

cadmium orange dense

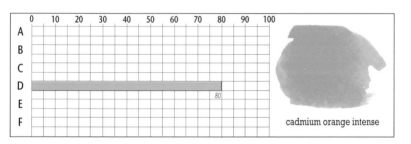

cadmium orange intense

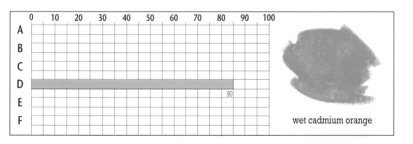

wet cadmium orange

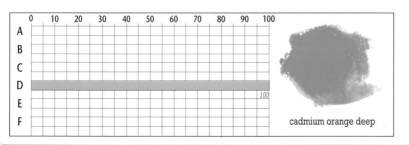

cadmium orange deep

SECONDARY COLORS:
ORANGE + VIOLET

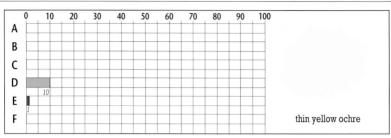

thin yellow ochre

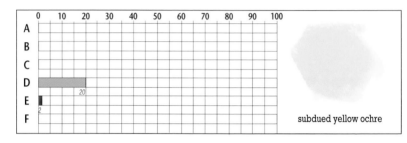

subdued yellow ochre

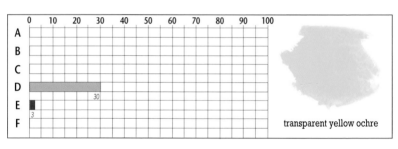

transparent yellow ochre

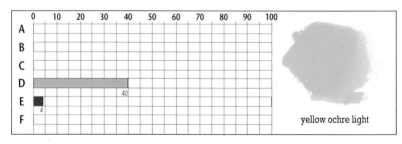

yellow ochre light

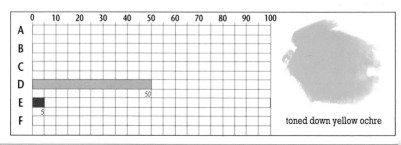

toned down yellow ochre

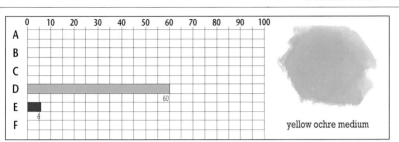

yellow ochre medium

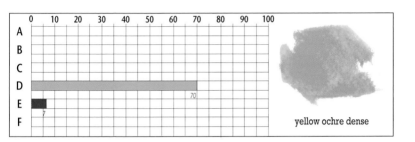

yellow ochre dense

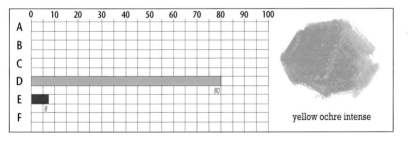

yellow ochre intense

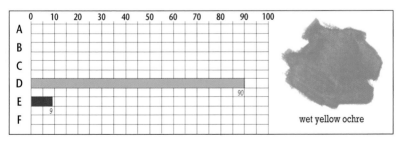

wet yellow ochre

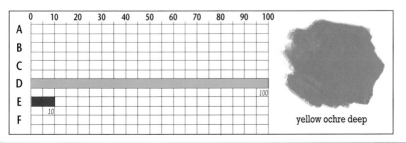

yellow ochre deep

SECONDARY COLORS
ORANGE + VIOLET

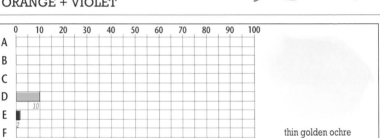

	0	10	20	30	40	50	60	70	80	90	100
A											
B											
C											
D	10										
E	2										
F											

thin golden ochre

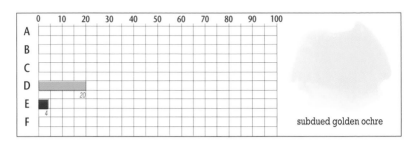

	0	10	20	30	40	50	60	70	80	90	100
A											
B											
C											
D			20								
E	4										
F											

subdued golden ochre

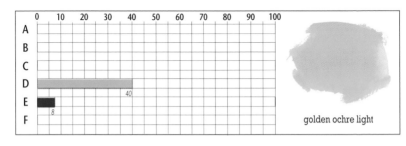

	0	10	20	30	40	50	60	70	80	90	100
A											
B											
C											
D				30							
E	6										
F											

transparent golden ochre

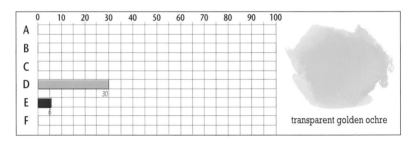

	0	10	20	30	40	50	60	70	80	90	100
A											
B											
C											
D					40						
E	8										
F											

golden ochre light

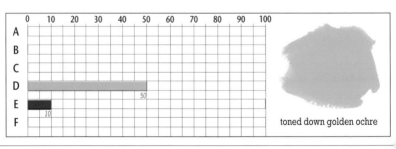

	0	10	20	30	40	50	60	70	80	90	100
A											
B											
C											
D						50					
E	10										
F											

toned down golden ochre

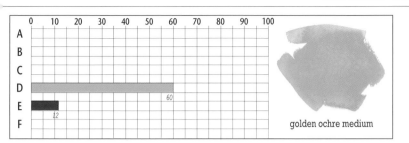

golden ochre medium

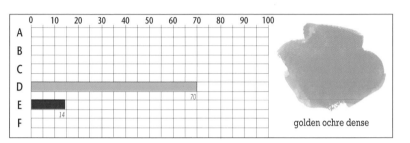

golden ochre dense

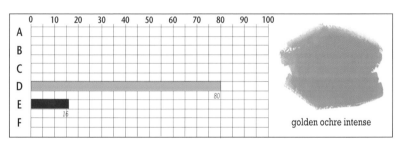

golden ochre intense

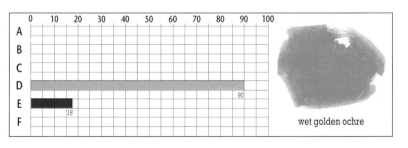

wet golden ochre

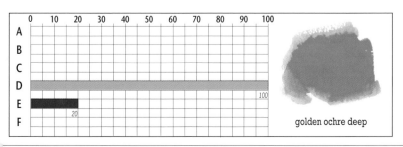

golden ochre deep

SECONDARY COLORS
ORANGE + VIOLET

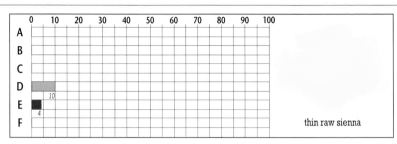

thin raw sienna

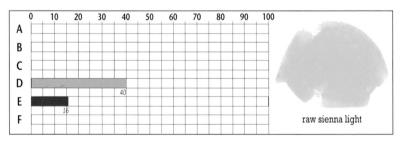

subdued raw sienna

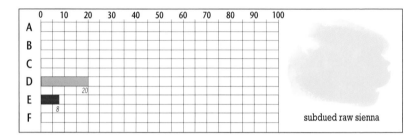

transparent raw sienna

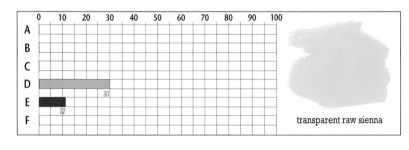

raw sienna light

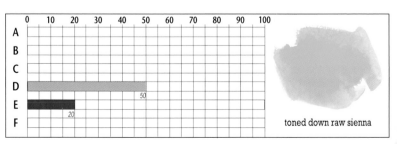

toned down raw sienna

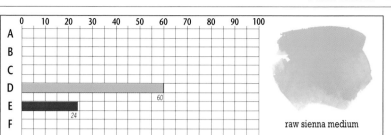

raw sienna medium

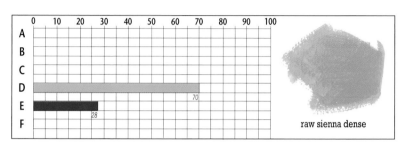

raw sienna dense

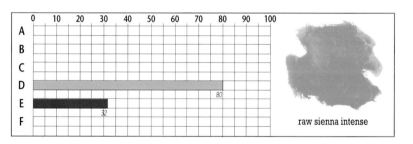

raw sienna intense

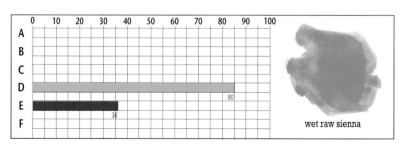

wet raw sienna

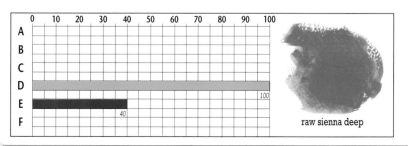

raw sienna deep

SECONDARY COLORS
ORANGE + VIOLET

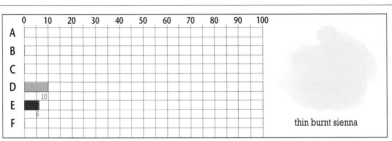

thin burnt sienna

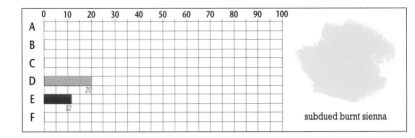

subdued burnt sienna

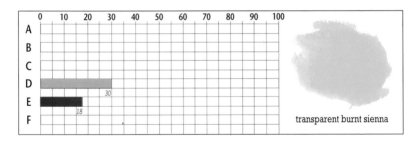

transparent burnt sienna

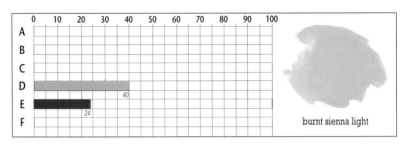

burnt sienna light

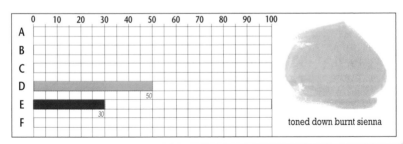

toned down burnt sienna

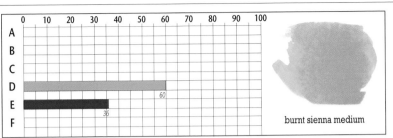

burnt sienna medium

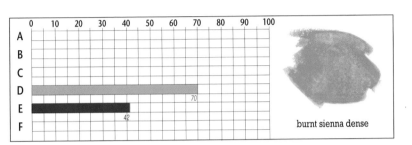

burnt sienna dense

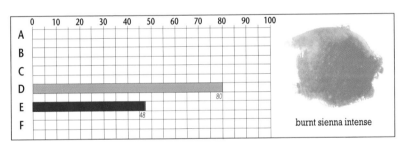

burnt sienna intense

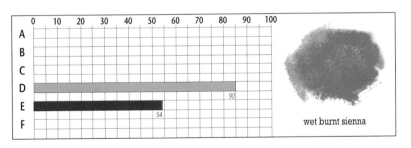

wet burnt sienna

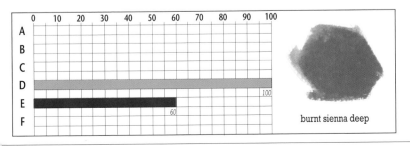

burnt sienna deep

SECONDARY COLORS
ORANGE + VIOLET

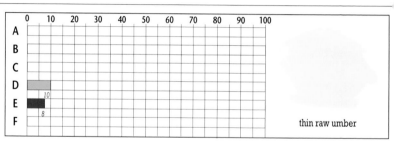

thin raw umber

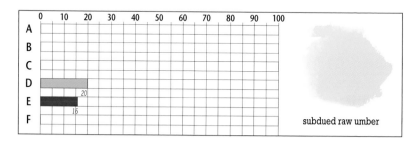

subdued raw umber

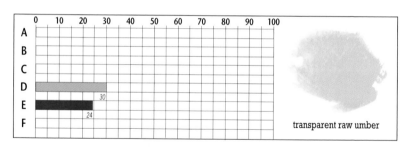

transparent raw umber

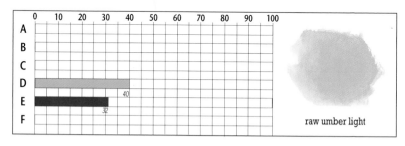

raw umber light

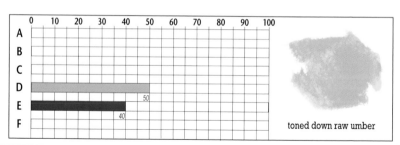

toned down raw umber

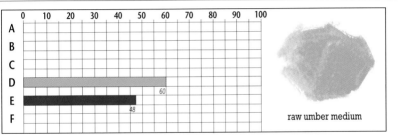

	0	10	20	30	40	50	60	70	80	90	100

A
B
C
D (60)
E (48)
F

raw umber medium

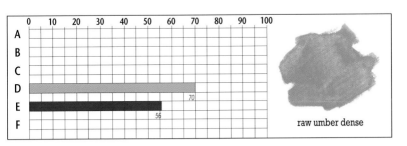

A
B
C
D (70)
E (56)
F

raw umber dense

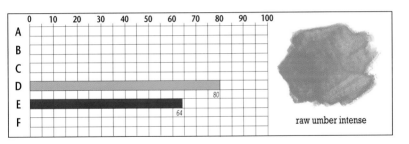

A
B
C
D (80)
E (64)
F

raw umber intense

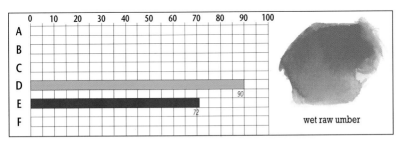

A
B
C
D (90)
E (72)
F

wet raw umber

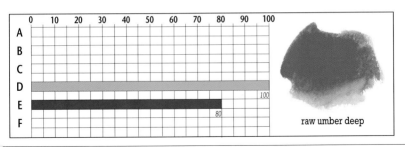

A
B
C
D (100)
E (80)
F

raw umber deep

SECONDARY COLORS
ORANGE + VIOLET

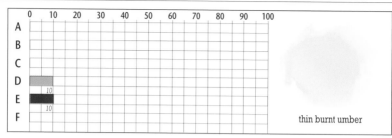

thin burnt umber

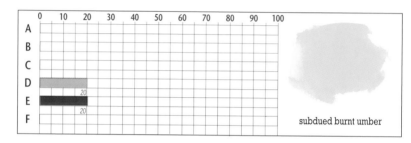

subdued burnt umber

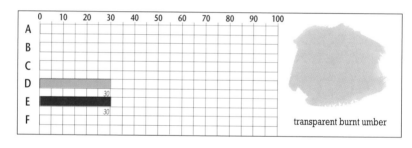

transparent burnt umber

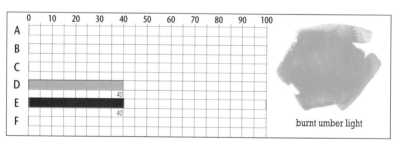

burnt umber light

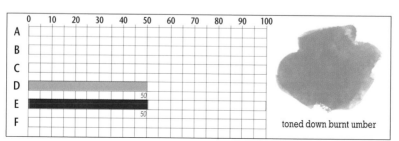

toned down burnt umber

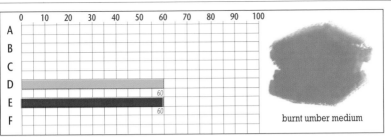

burnt umber medium

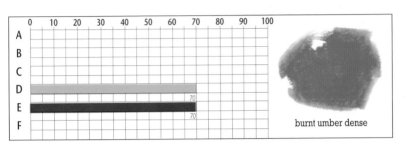

burnt umber dense

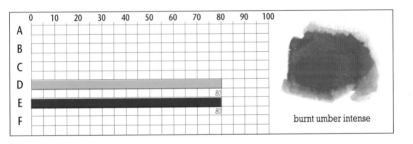

burnt umber intense

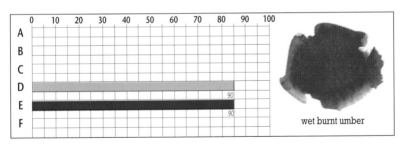

wet burnt umber

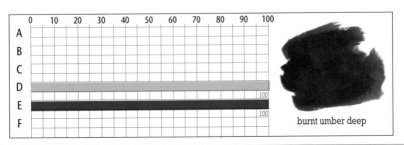

burnt umber deep

SECONDARY COLORS:
VIOLET + GREEN

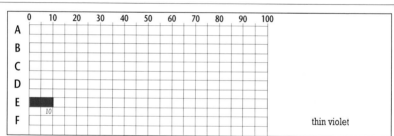

thin violet

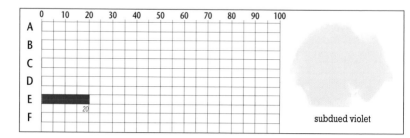

subdued violet

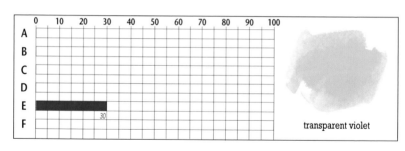

transparent violet

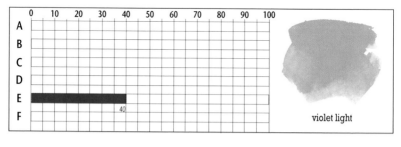

violet light

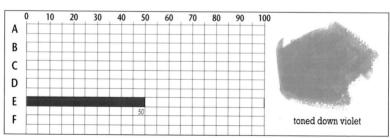

toned down violet

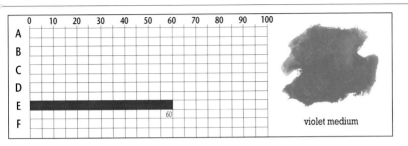

violet medium

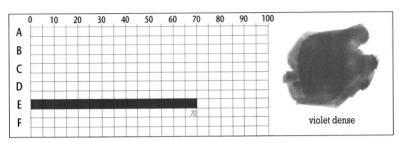

violet dense

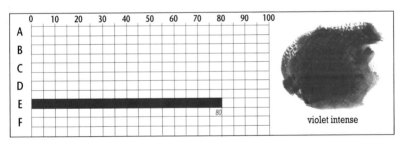

violet intense

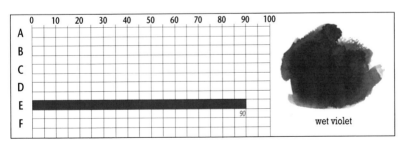

wet violet

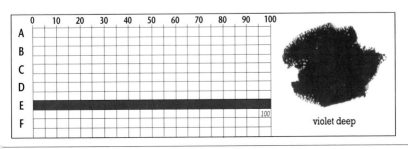

violet deep

SECONDARY COLORS:
VIOLET + GREEN

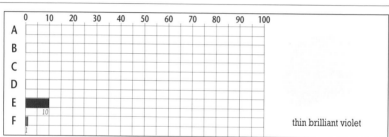

	0	10	20	30	40	50	60	70	80	90	100
A											
B											
C											
D											
E	10										
F	1										

thin brilliant violet

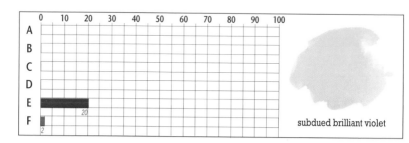

	0	10	20	30	40	50	60	70	80	90	100
A											
B											
C											
D											
E	20										
F	2										

subdued brilliant violet

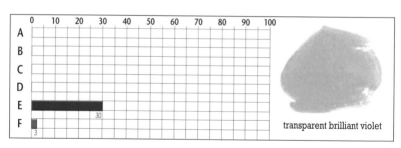

	0	10	20	30	40	50	60	70	80	90	100
A											
B											
C											
D											
E	30										
F	3										

transparent brilliant violet

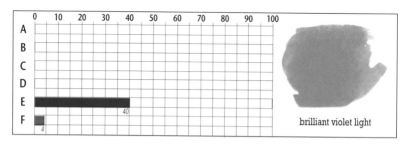

	0	10	20	30	40	50	60	70	80	90	100
A											
B											
C											
D											
E	40										
F	4										

brilliant violet light

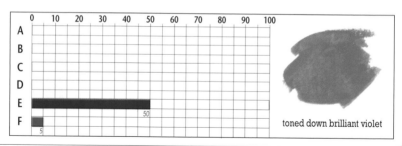

	0	10	20	30	40	50	60	70	80	90	100
A											
B											
C											
D											
E	50										
F	5										

toned down brilliant violet

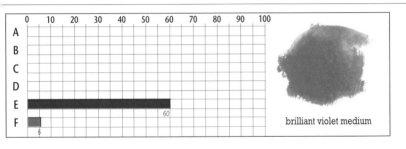

brilliant violet medium

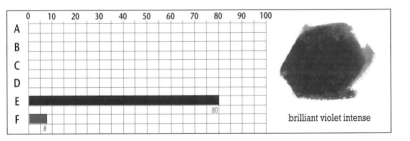

brilliant violet dense

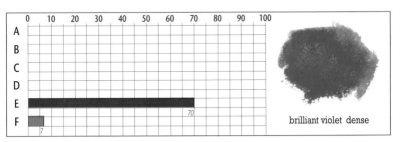

brilliant violet intense

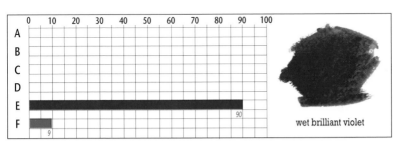

wet brilliant violet

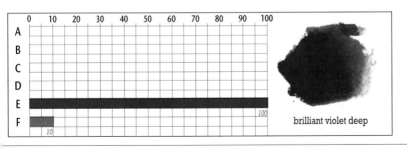

brilliant violet deep

SECONDARY COLORS
VIOLET + GREEN

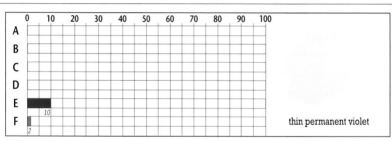

	0	10	20	30	40	50	60	70	80	90	100
A											
B											
C											
D											
E	10										
F	2										

thin permanent violet

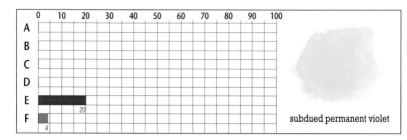

	0	10	20	30	40	50	60	70	80	90	100
A											
B											
C											
D											
E	20										
F	4										

subdued permanent violet

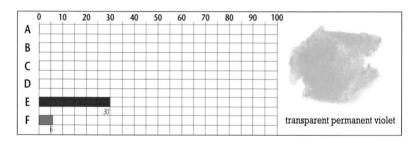

	0	10	20	30	40	50	60	70	80	90	100
A											
B											
C											
D											
E	30										
F	6										

transparent permanent violet

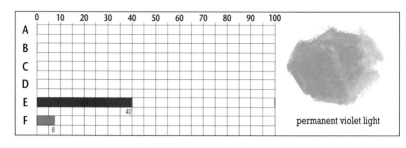

	0	10	20	30	40	50	60	70	80	90	100
A											
B											
C											
D											
E	40										
F	8										

permanent violet light

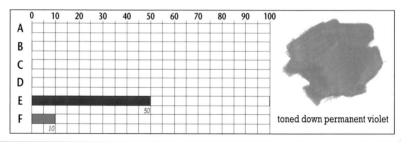

	0	10	20	30	40	50	60	70	80	90	100
A											
B											
C											
D											
E	50										
F	10										

toned down permanent violet

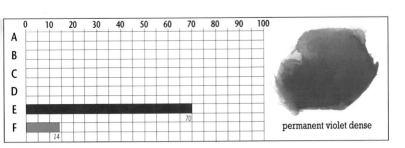

	0	10	20	30	40	50	60	70	80	90	100
A											
B											
C											
D											
E											
F											

60

12

permanent violet medium

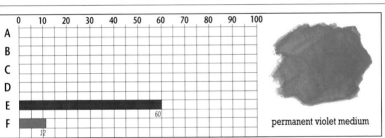

	0	10	20	30	40	50	60	70	80	90	100
A											
B											
C											
D											
E											
F											

70

14

permanent violet dense

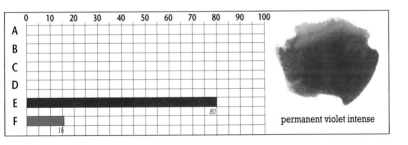

	0	10	20	30	40	50	60	70	80	90	100
A											
B											
C											
D											
E											
F											

80

16

permanent violet intense

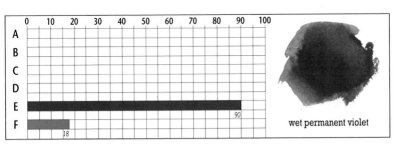

	0	10	20	30	40	50	60	70	80	90	100
A											
B											
C											
D											
E											
F											

90

18

wet permanent violet

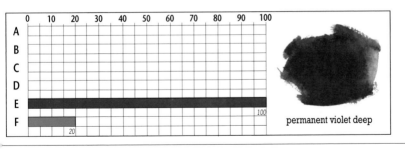

	0	10	20	30	40	50	60	70	80	90	100
A											
B											
C											
D											
E											
F											

100

20

permanent violet deep

SECONDARY COLORS:
VIOLET + GREEN

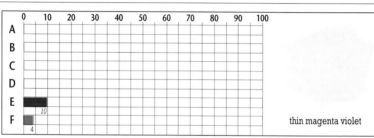

thin magenta violet

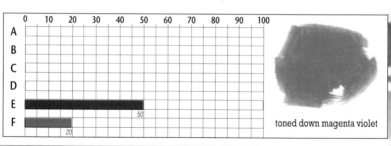

subdued magenta violet

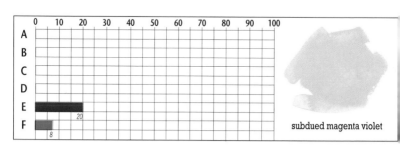

transparent magenta violet

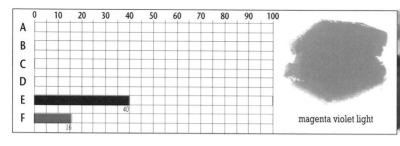

magenta violet light

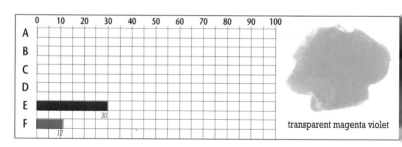

toned down magenta violet

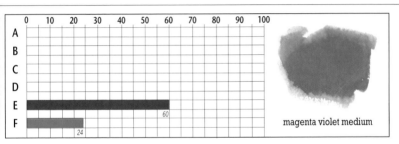

magenta violet medium

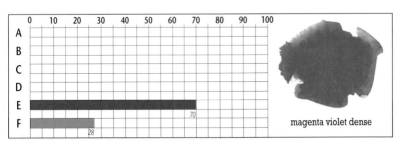

magenta violet dense

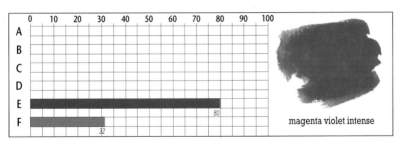

magenta violet intense

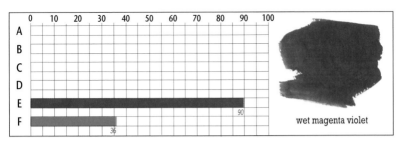

wet magenta violet

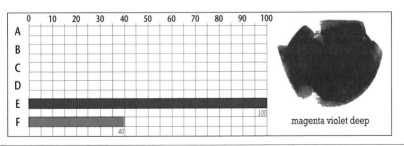

magenta violet deep

SECONDARY COLORS:
VIOLET + GREEN

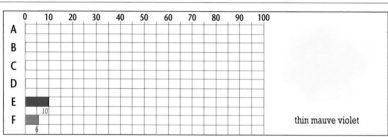

	0	10	20	30	40	50	60	70	80	90	100
A											
B											
C											
D											
E	10										
F	6										

thin mauve violet

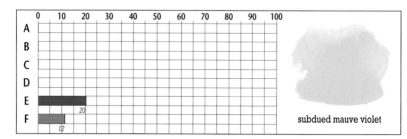

	0	10	20	30	40	50	60	70	80	90	100
A											
B											
C											
D											
E		20									
F	12										

subdued mauve violet

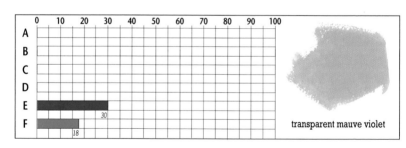

	0	10	20	30	40	50	60	70	80	90	100
A											
B											
C											
D											
E			30								
F		18									

transparent mauve violet

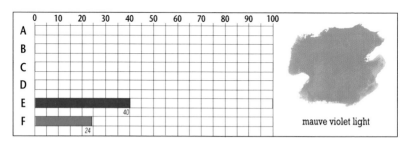

	0	10	20	30	40	50	60	70	80	90	100
A											
B											
C											
D											
E				40							
F			24								

mauve violet light

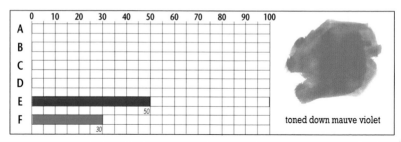

	0	10	20	30	40	50	60	70	80	90	100
A											
B											
C											
D											
E					50						
F			30								

toned down mauve violet

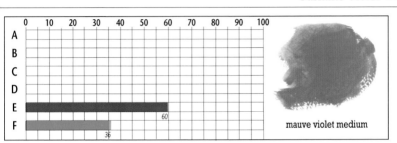

mauve violet medium

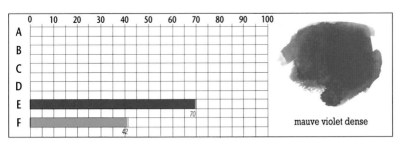

mauve violet dense

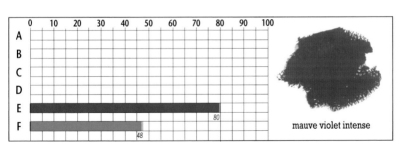

mauve violet intense

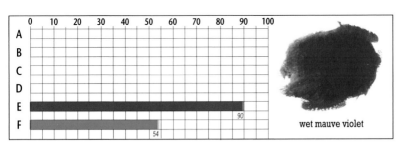

wet mauve violet

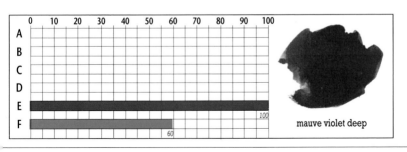

mauve violet deep

SECONDARY COLORS:
VIOLET + GREEN

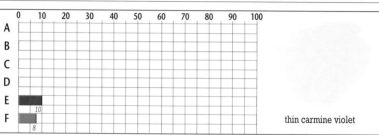

thin carmine violet

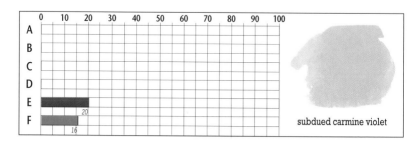

subdued carmine violet

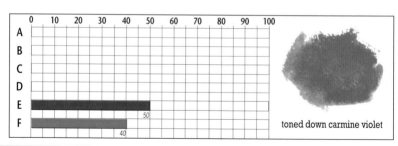

transparent carmine violet

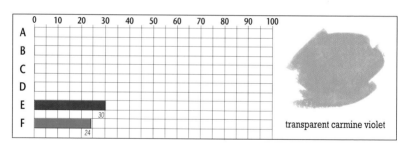

carmine violet light

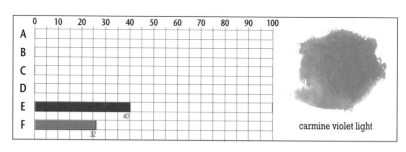

toned down carmine violet

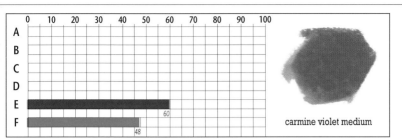

carmine violet medium

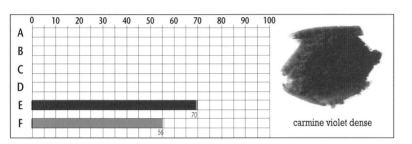

carmine violet dense

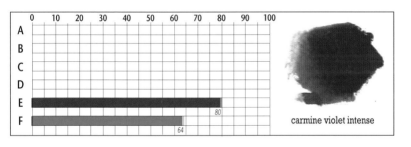

carmine violet intense

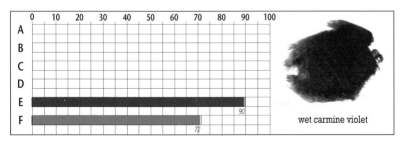

wet carmine violet

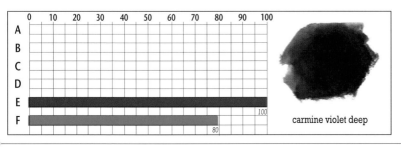

carmine violet deep

SECONDARY COLORS:
VIOLET + GREEN

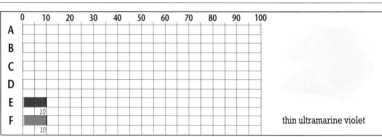

	0	10	20	30	40	50	60	70	80	90	100

A
B
C
D
E 10
F 10

thin ultramarine violet

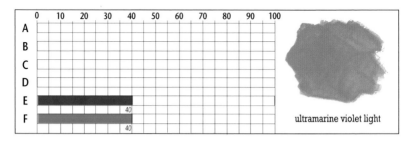

	0	10	20	30	40	50	60	70	80	90	100

A
B
C
D
E 20
F 20

subdued ultramarine violet

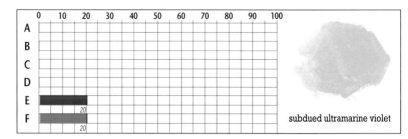

	0	10	20	30	40	50	60	70	80	90	100

A
B
C
D
E 30
F 30

transparent ultramarine violet

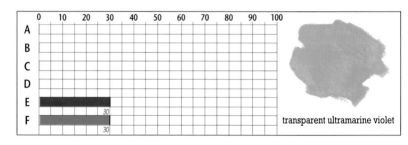

	0	10	20	30	40	50	60	70	80	90	100

A
B
C
D
E 40
F 40

ultramarine violet light

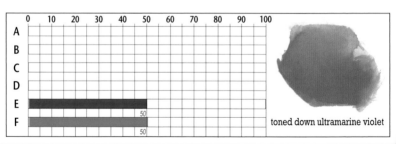

	0	10	20	30	40	50	60	70	80	90	100

A
B
C
D
E 50
F 50

toned down ultramarine violet

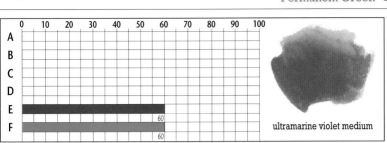

	0	10	20	30	40	50	60	70	80	90	100
A											
B											
C											
D											
E							60				
F							60				

ultramarine violet medium

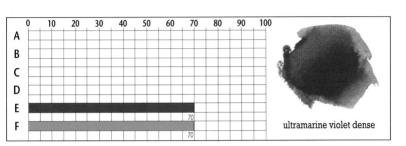

	0	10	20	30	40	50	60	70	80	90	100
A											
B											
C											
D											
E								70			
F								70			

ultramarine violet dense

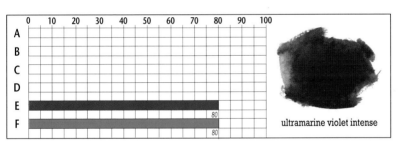

	0	10	20	30	40	50	60	70	80	90	100
A											
B											
C											
D											
E									80		
F									80		

ultramarine violet intense

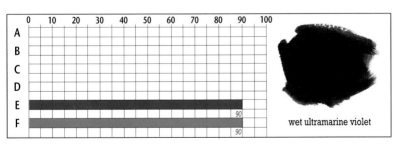

	0	10	20	30	40	50	60	70	80	90	100
A											
B											
C											
D											
E										90	
F										90	

wet ultramarine violet

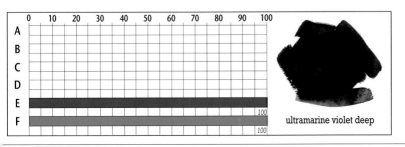

	0	10	20	30	40	50	60	70	80	90	100
A											
B											
C											
D											
E											100
F											100

ultramarine violet deep

SECONDARY COLORS:
GREEN + ORANGE

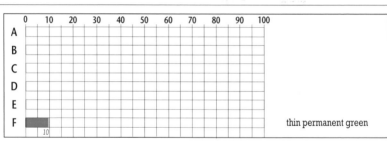

thin permanent green

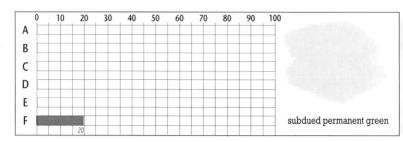

subdued permanent green

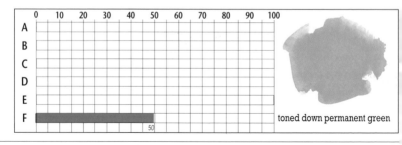

transparent permanent green

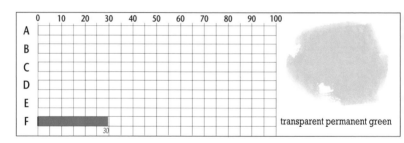

permanent green light

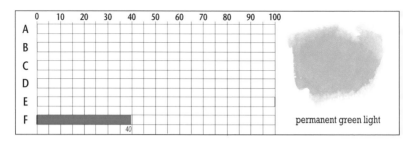

toned down permanent green

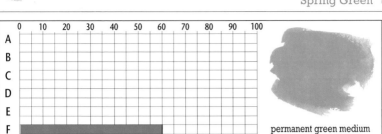

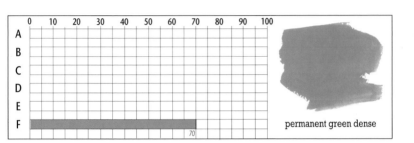

permanent green medium

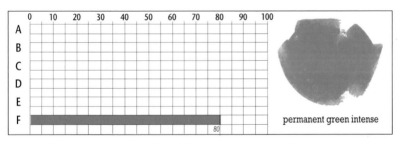

permanent green dense

permanent green intense

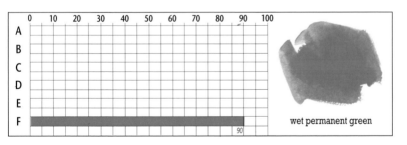

wet permanent green

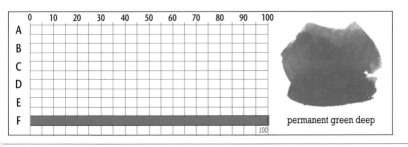

permanent green deep

SECONDARY COLORS:
GREEN + ORANGE

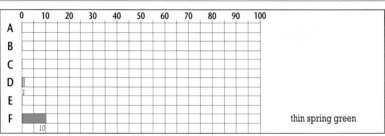

thin spring green

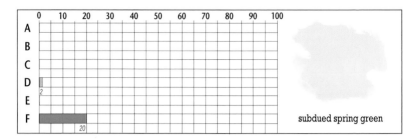

subdued spring green

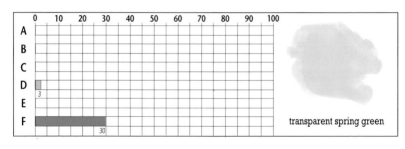

transparent spring green

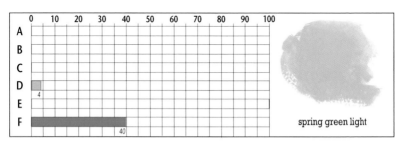

spring green light

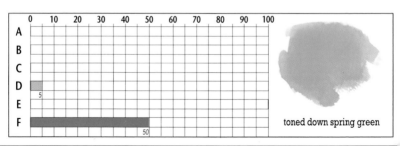

toned down spring green

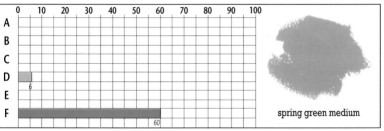

spring green medium

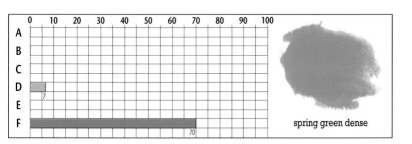

spring green dense

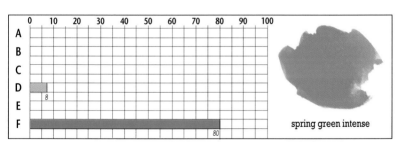

spring green intense

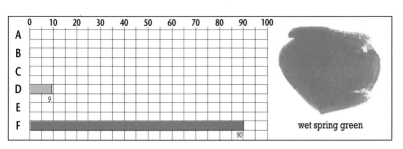

wet spring green

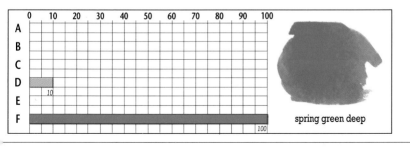

spring green deep

SECONDARY COLORS:
GREEN + ORANGE

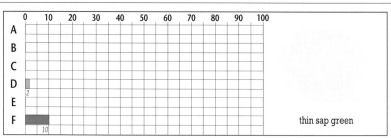

thin sap green

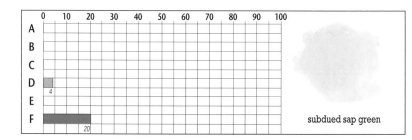

subdued sap green

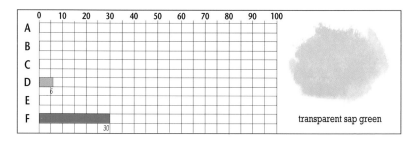

transparent sap green

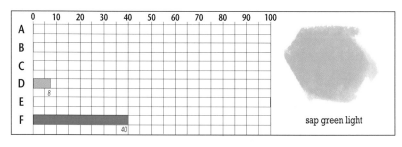

sap green light

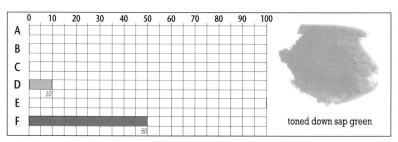

toned down sap green

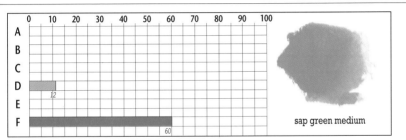

sap green medium

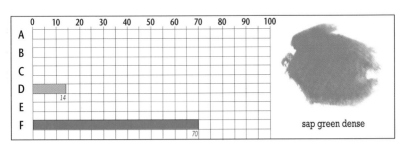

sap green dense

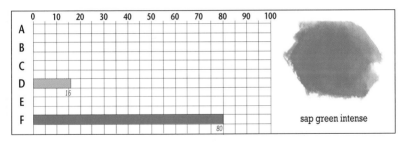

sap green intense

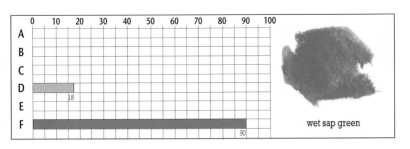

wet sap green

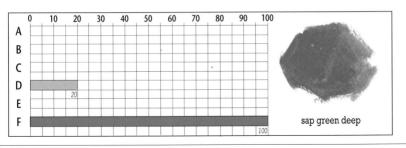

sap green deep

SECONDARY COLORS:
GREEN + ORANGE

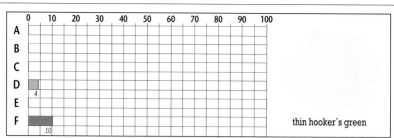

thin hooker's green

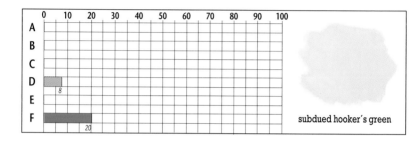

subdued hooker's green

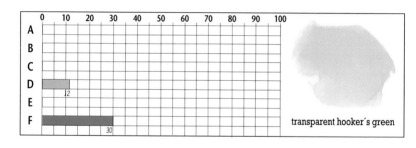

transparent hooker's green

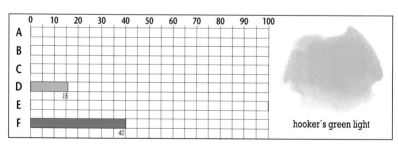

hooker's green light

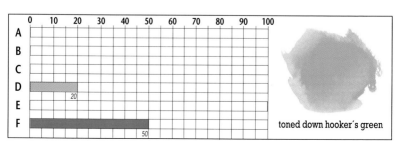

toned down hooker's green

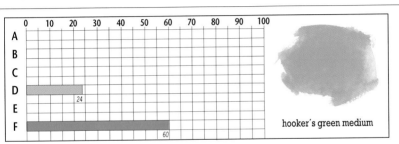

hooker´s green medium

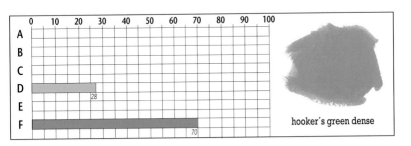

hooker´s green dense

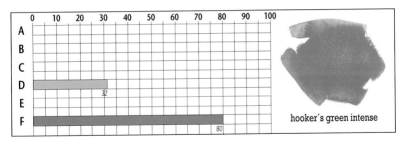

hooker´s green intense

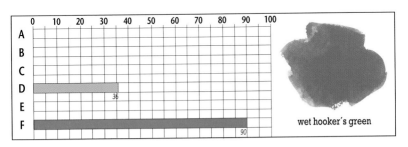

wet hooker´s green

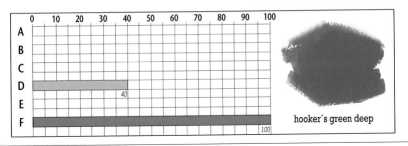

hooker´s green deep

SECONDARY COLORS:
GREEN + ORANGE

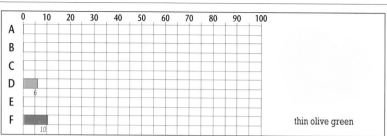

	0	10	20	30	40	50	60	70	80	90	100
A											
B											
C											
D	6										
E											
F	10										

thin olive green

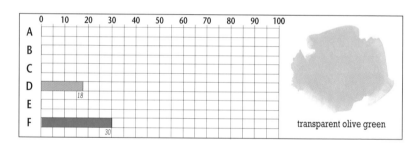

	0	10	20	30	40	50	60	70	80	90	100
A											
B											
C											
D	12										
E											
F		20									

subdued olive green

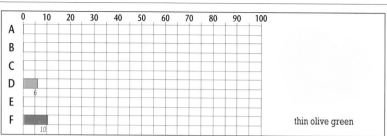

	0	10	20	30	40	50	60	70	80	90	100
A											
B											
C											
D	18										
E											
F		30									

transparent olive green

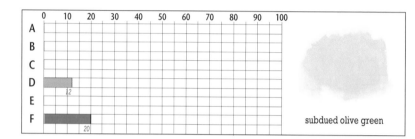

	0	10	20	30	40	50	60	70	80	90	100
A											
B											
C											
D	24										
E											
F			40								

olive green light

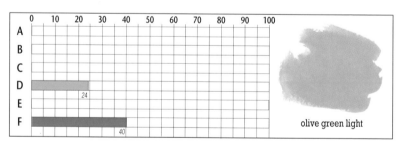

	0	10	20	30	40	50	60	70	80	90	100
A											
B											
C											
D	30										
E											
F			50								

toned down olive green

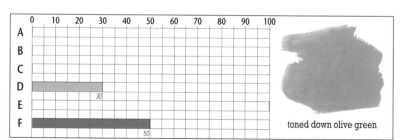

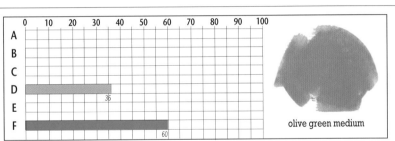

olive green medium

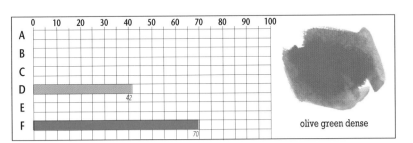

olive green dense

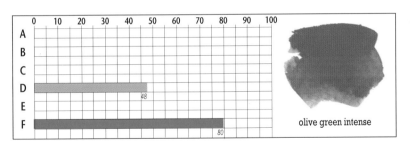

olive green intense

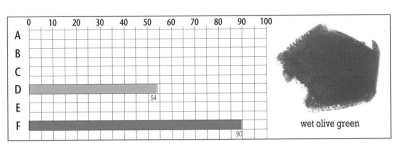

wet olive green

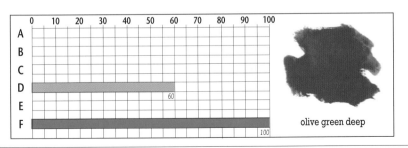

olive green deep

SECONDARY COLORS:
GREEN + ORANGE

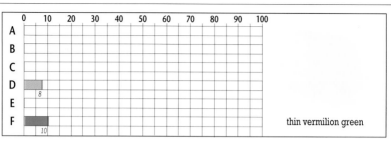

	0	10	20	30	40	50	60	70	80	90	100
A											
B											
C											
D	8										
E											
F	10										

thin vermilion green

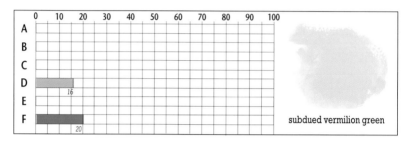

	0	10	20	30	40	50	60	70	80	90	100
A											
B											
C											
D	16										
E											
F	20										

subdued vermilion green

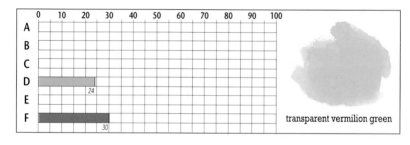

	0	10	20	30	40	50	60	70	80	90	100
A											
B											
C											
D	24										
E											
F	30										

transparent vermilion green

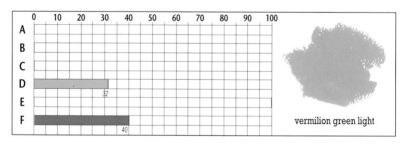

	0	10	20	30	40	50	60	70	80	90	100
A											
B											
C											
D	32										
E											
F	40										

vermilion green light

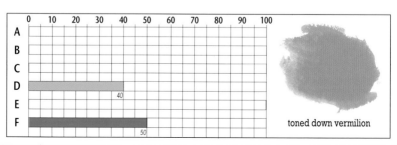

	0	10	20	30	40	50	60	70	80	90	100
A											
B											
C											
D	40										
E											
F	50										

toned down vermilion

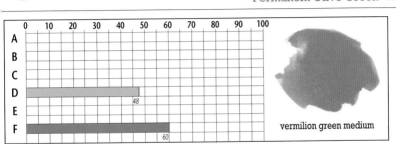

vermilion green medium

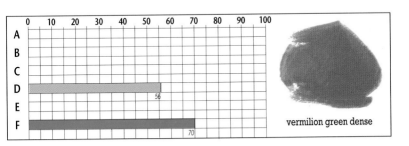

vermilion green dense

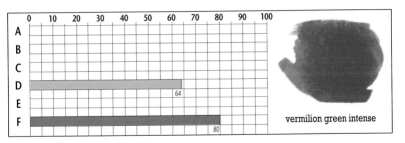

vermilion green intense

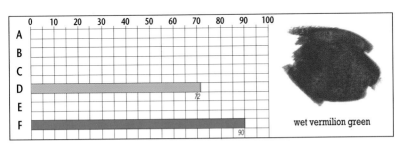

wet vermilion green

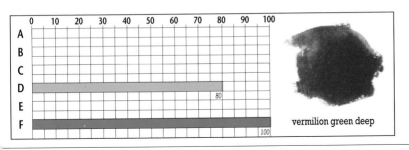

vermilion green deep

SECONDARY COLORS:
GREEN + ORANGE

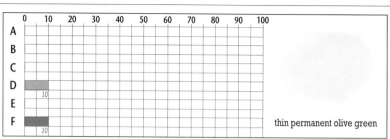

thin permanent olive green

subdued permanent
olive green

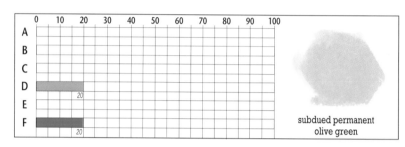

transparent permanent
olive green

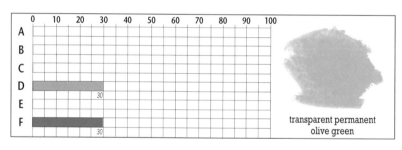

permanent olive green light

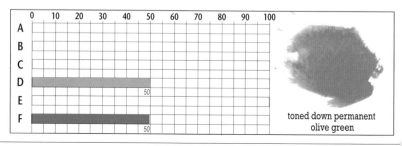

toned down permanent
olive green

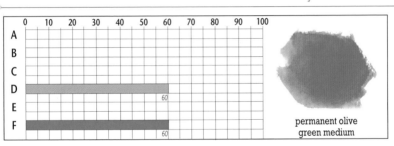

	0	10	20	30	40	50	60	70	80	90	100
A											
B											
C											
D							60				
E											
F							60				

permanent olive
green medium

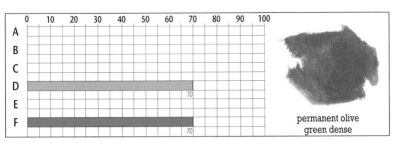

	0	10	20	30	40	50	60	70	80	90	100
A											
B											
C											
D								70			
E											
F								70			

permanent olive
green dense

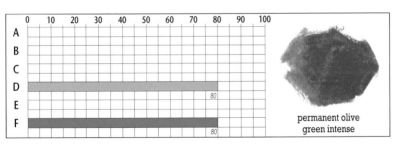

	0	10	20	30	40	50	60	70	80	90	100
A											
B											
C											
D									80		
E											
F									80		

permanent olive
green intense

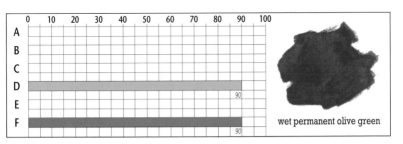

	0	10	20	30	40	50	60	70	80	90	100
A											
B											
C											
D										90	
E											
F										90	

wet permanent olive green

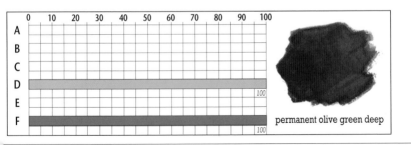

	0	10	20	30	40	50	60	70	80	90	100
A											
B											
C											
D											100
E											
F											100

permanent olive green deep

SCALE OF BLACKS

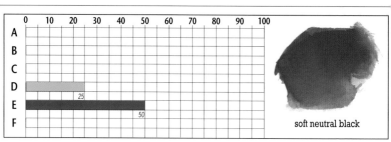

soft neutral black

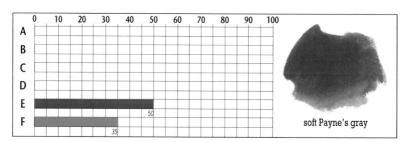

soft Payne's gray

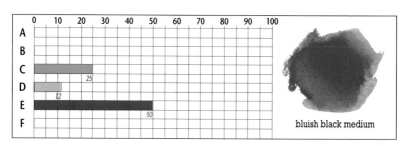

bluish black medium

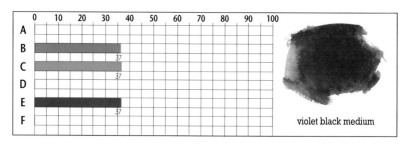

violet black medium

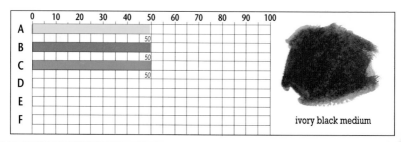

ivory black medium

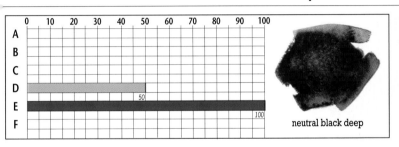

neutral black deep

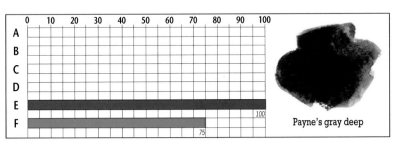

Payne's gray deep

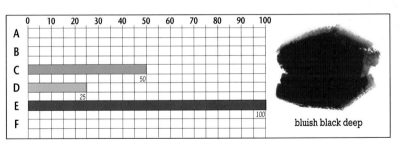

bluish black deep

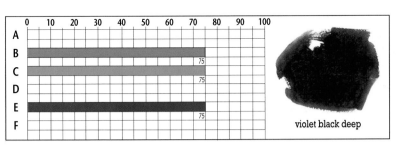

violet black deep

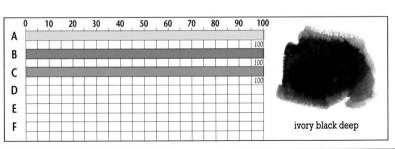

ivory black deep

Original title of the book in Spanish: *Mezcla de Colores.*
1. Acuarela
© Copyright Parramón Ediciones, S.A. 1996—World Rights.
Published by Parramón Ediciones, S.A., Barcelona, Spain.
Author: Parramon's Editorial Team
Illustrations: Parramon's Editorial Team
Copyright of the English edition © 1996 by Barron's
Educational Series, Inc.

All inquiries should be addressed to:
Barron's Educational Series, Inc.
250 Wireless Boulevard
Hauppauge, New York 11788

International Standard Book No. 0-8120-6619-7

Library of Congress Catalog Card No. 96-85320

Printed in Spain
987654321

Note: The titles that appear at the top of the odd-numbered
pages correspond to:

The previous chapter
The current chapter
The following chapter